Annette Kelm Subjects and Objects

Verlag der Buchhandlung
Walther König, Köln

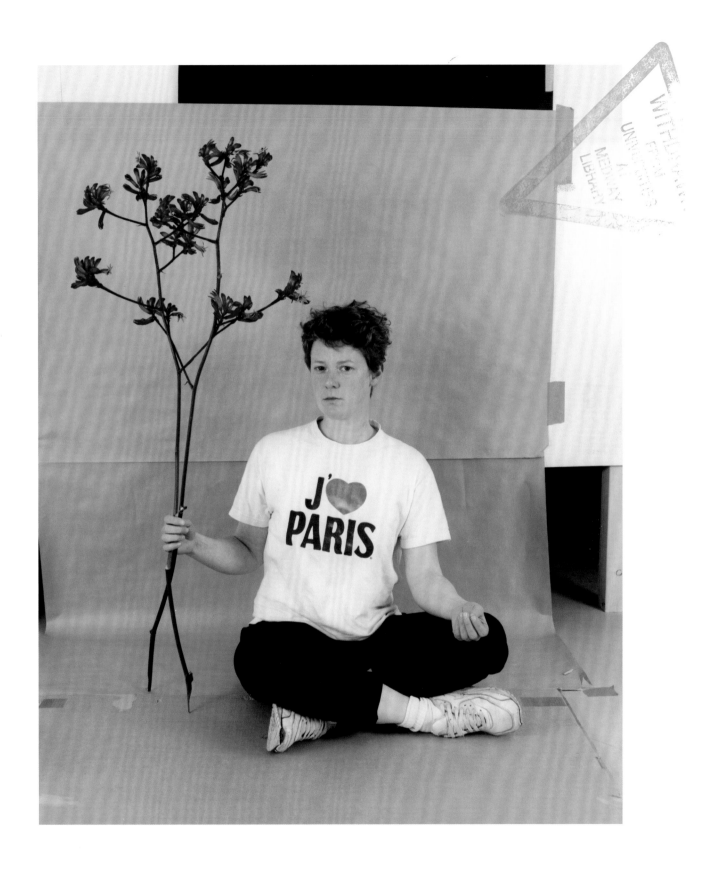

J'aime Paris, 2013

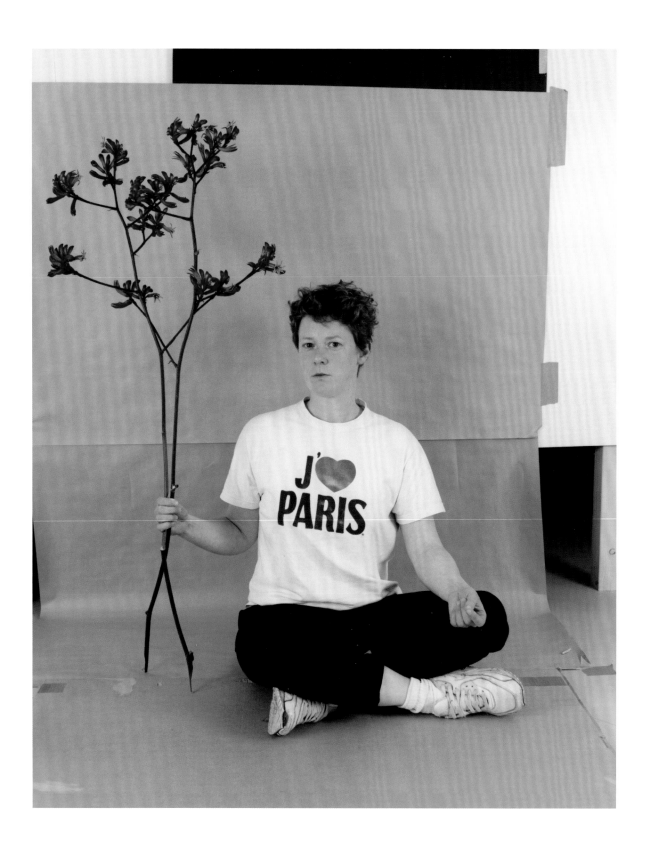

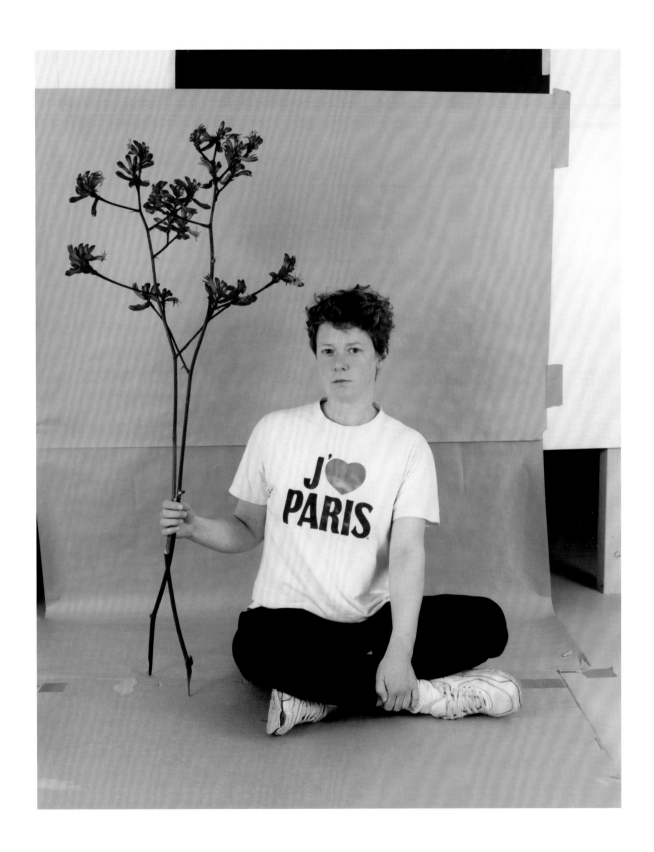

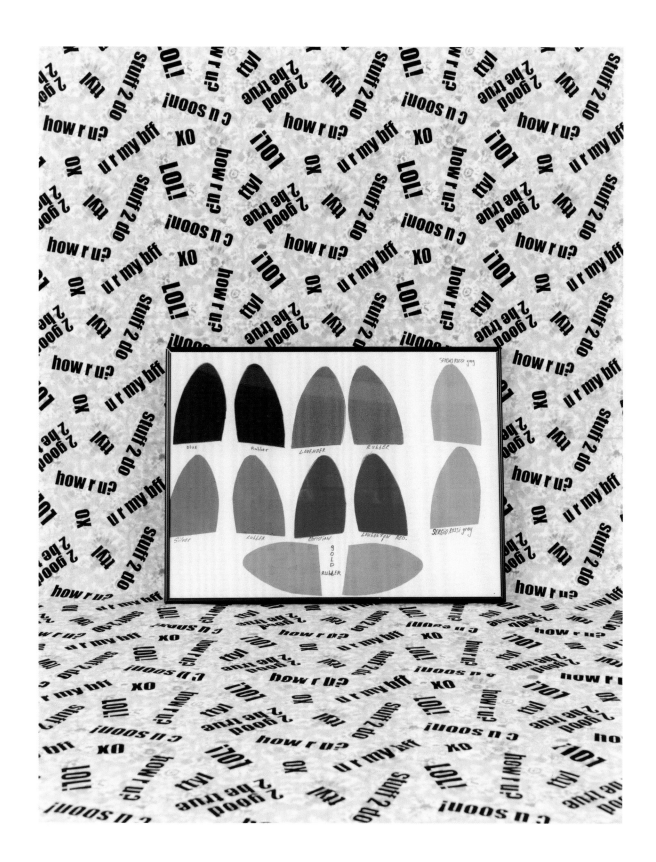

Soles, LOL!, C U SOON, XO, STUFF 2 DO, 2013

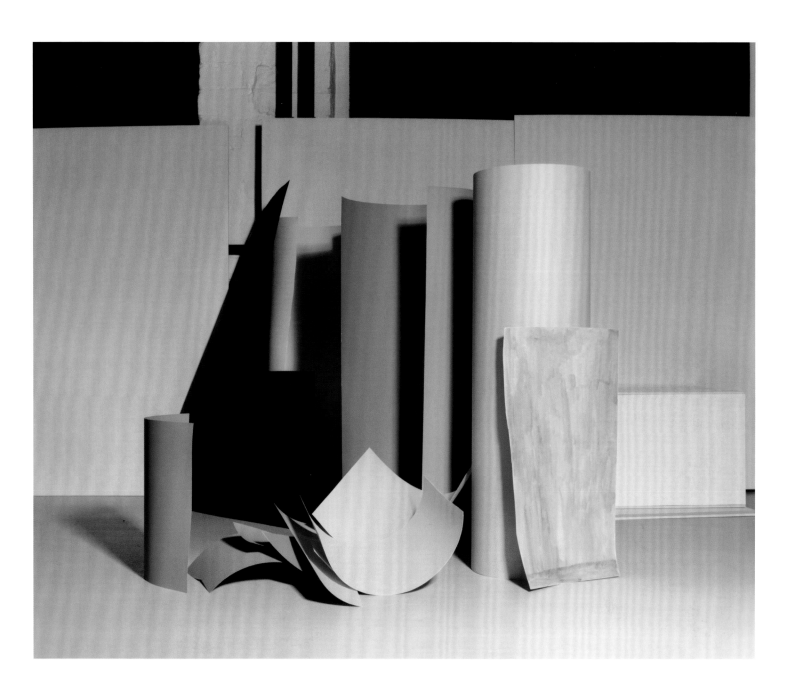

Materialtest, 2011

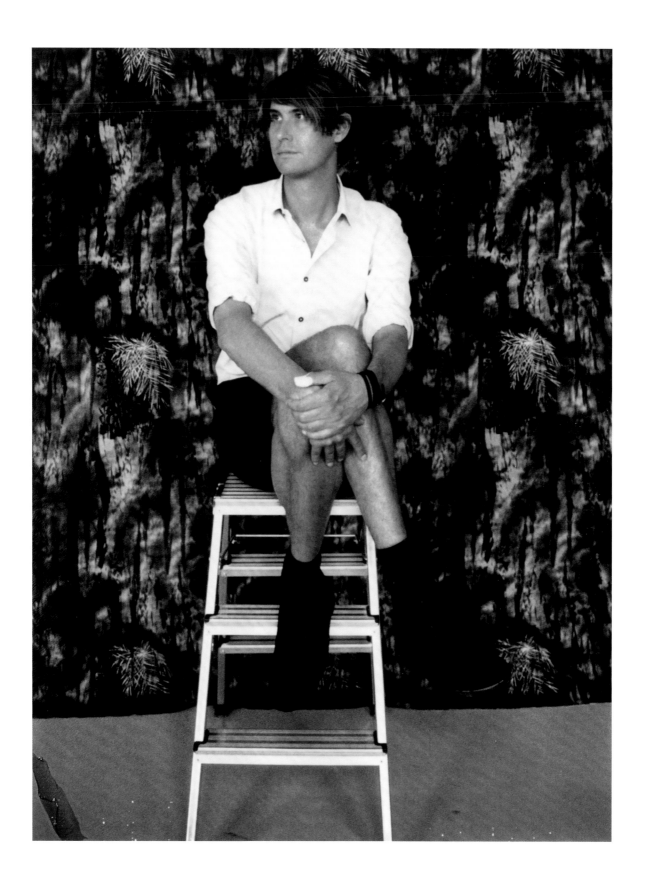

Untitled (Portrait on a Ladder), 2009

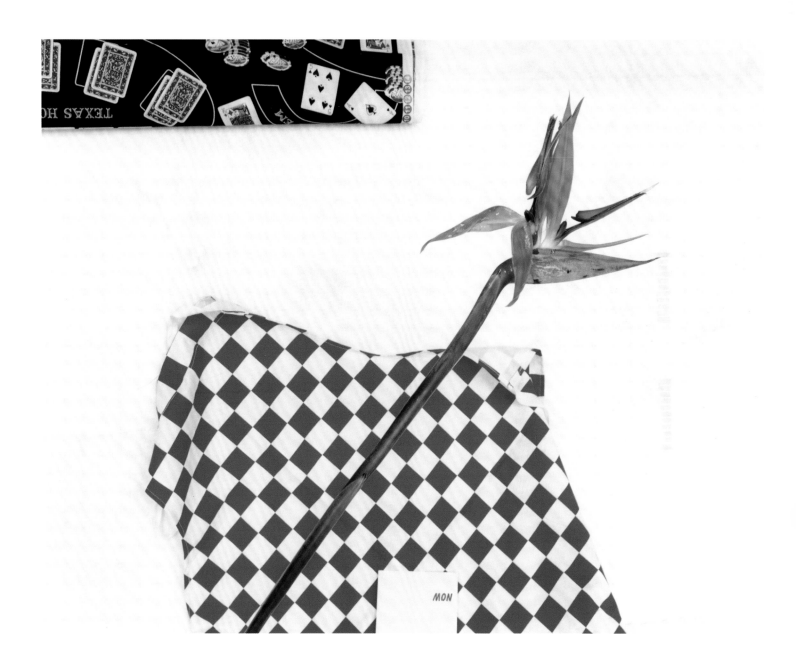

Untitled, 2010

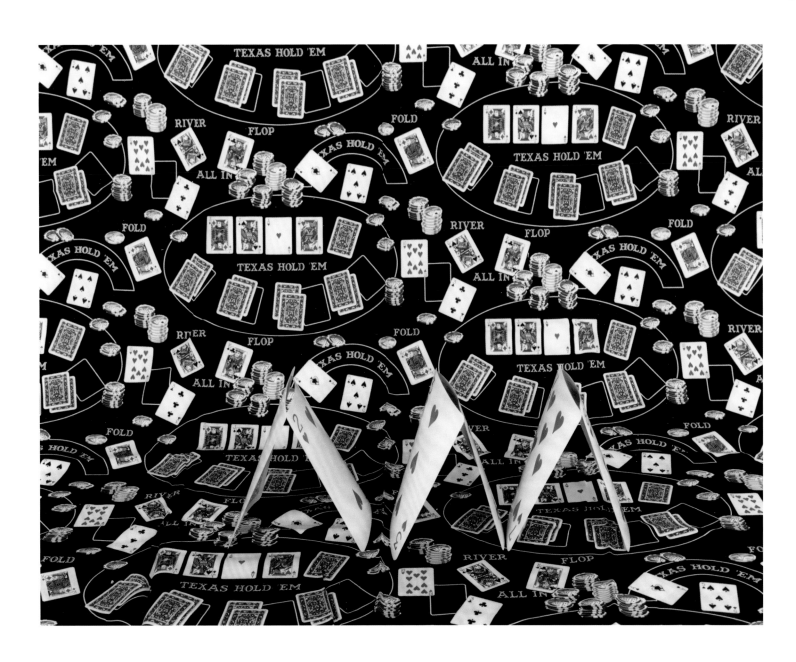

Untitled (Cards), 2010

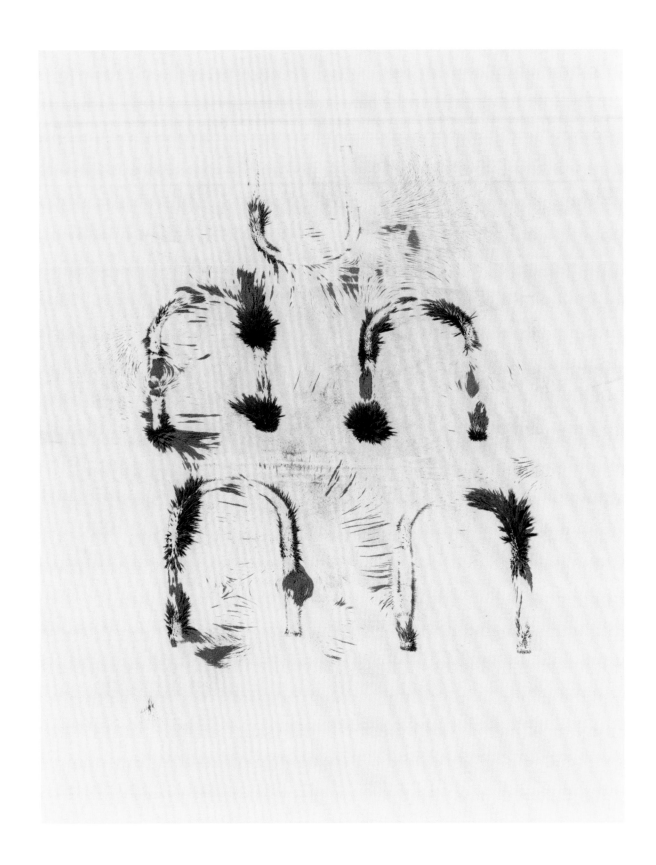

Untitled, 2012

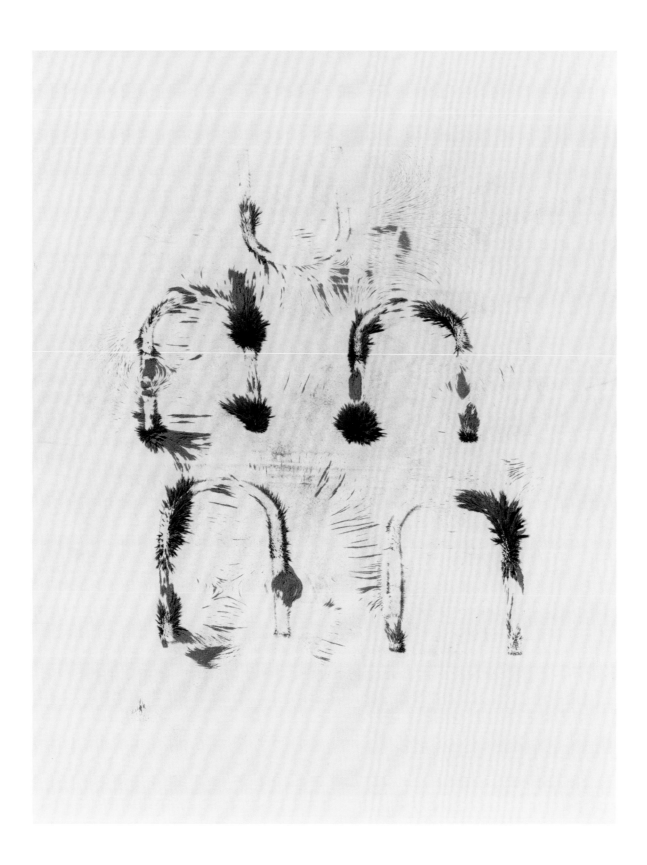

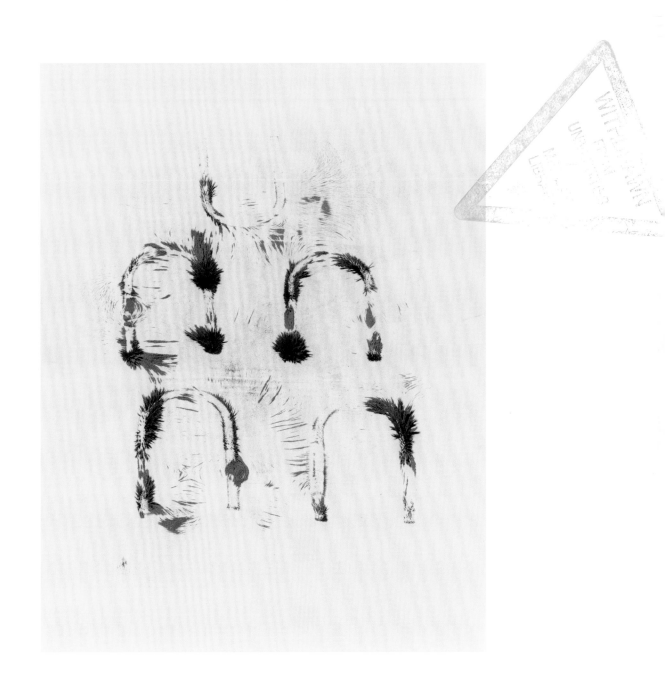

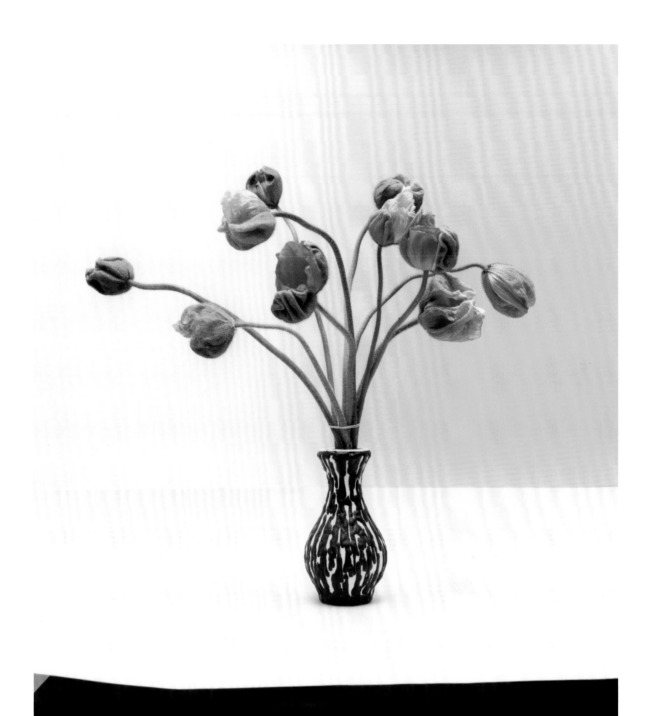

Untitled, 2012

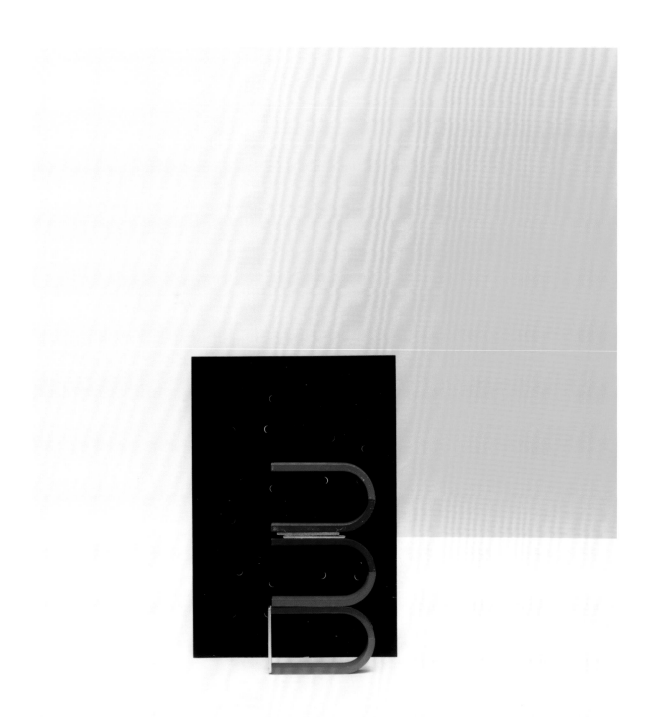

Untitled (Horseshoe Magnets 2), 2012

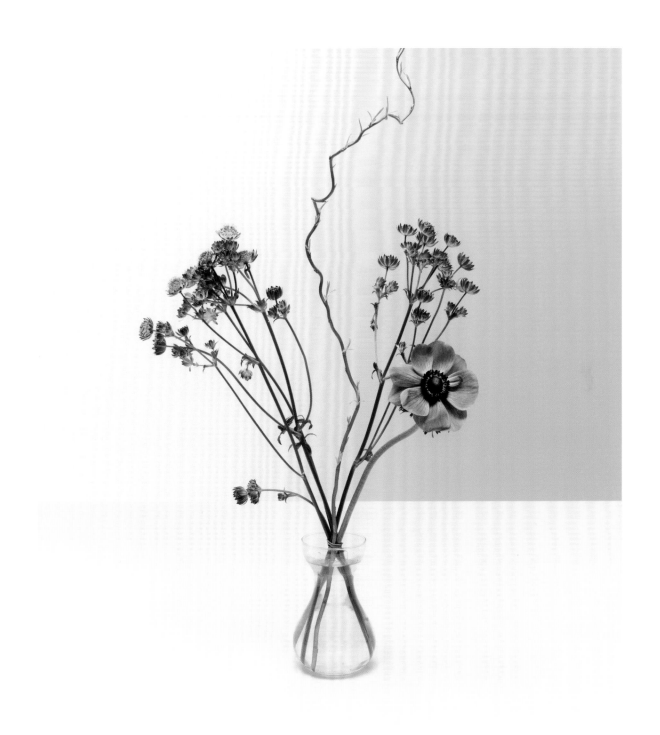

Bouquet, 2012

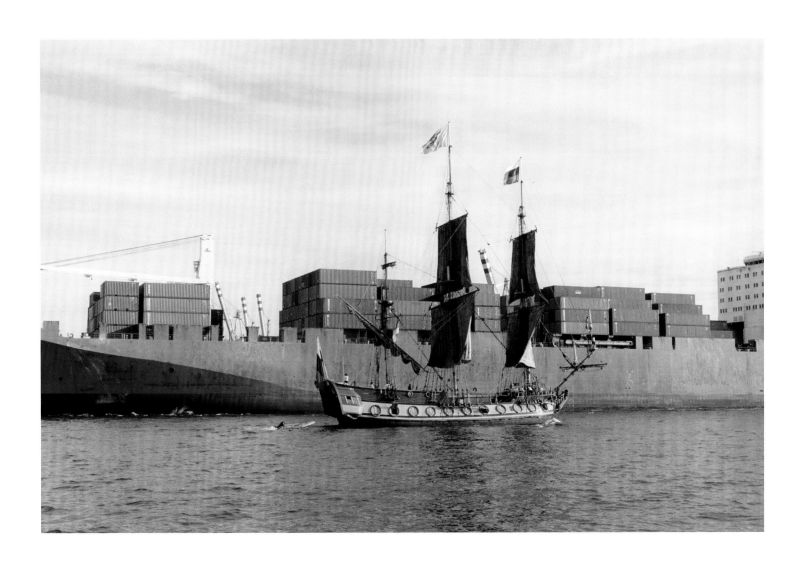

Untitled (Boats), 2009

Anna #1, 2011

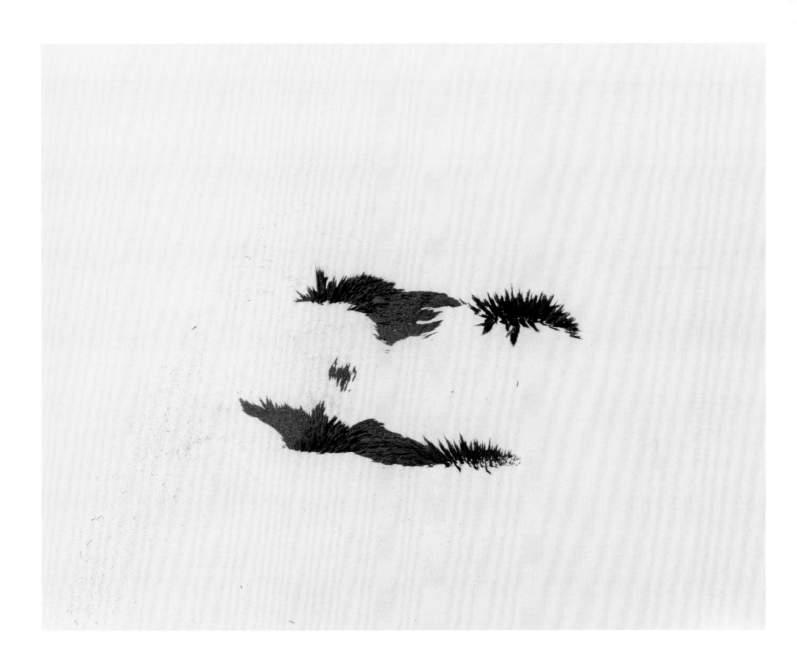

Iron Filings, Smile, 2013

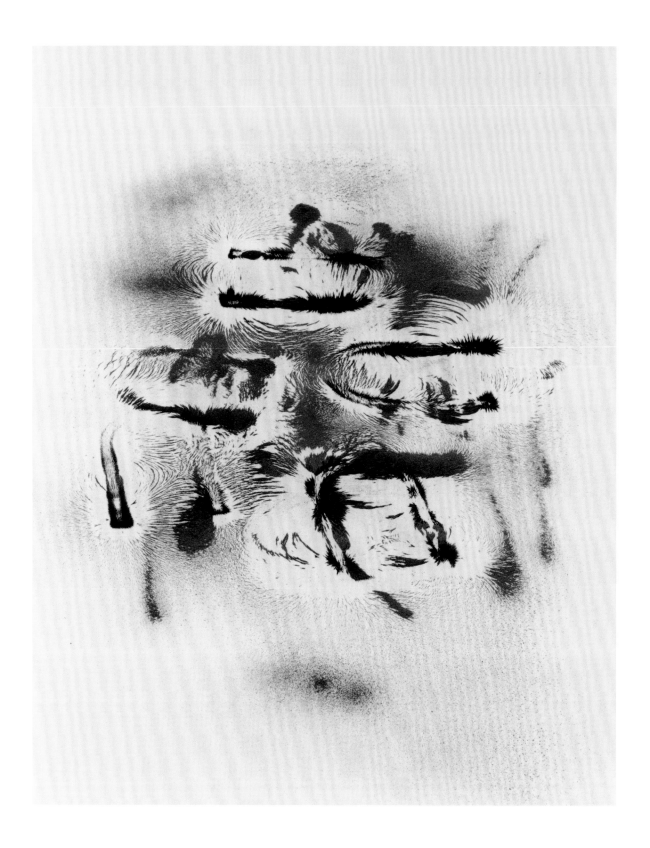

28 Untitled, 2012

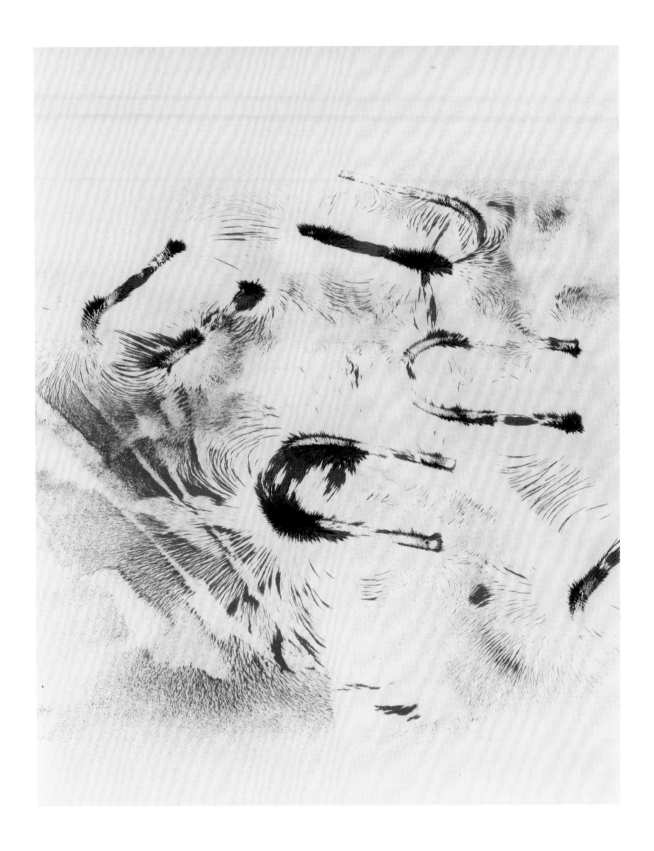

Untitled, 2012

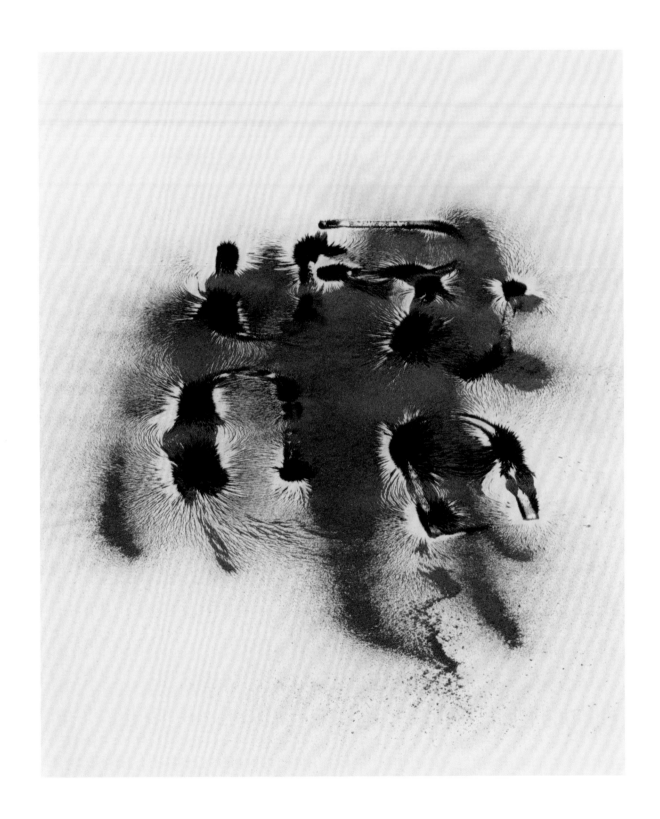

Untitled, 2012

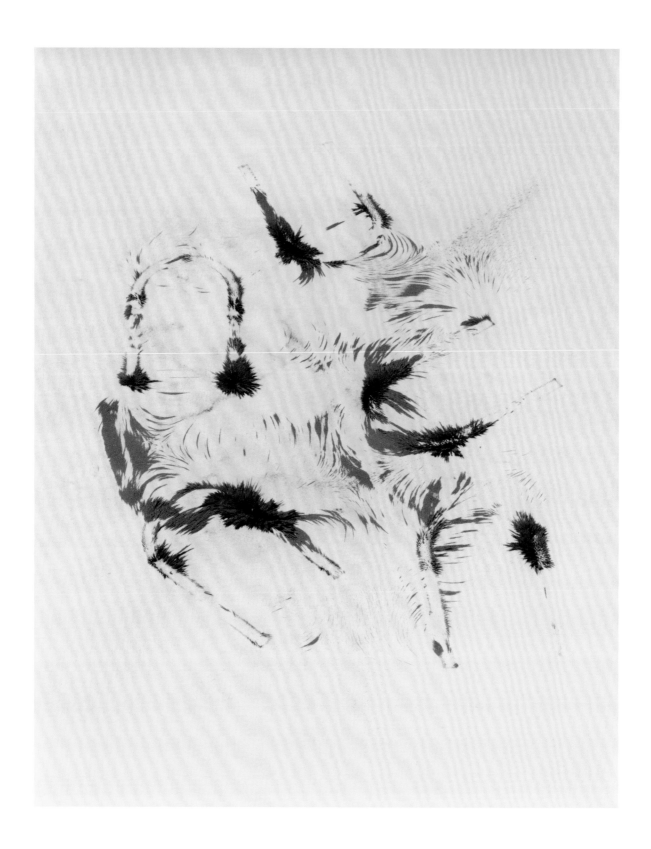

Untitled, 2012

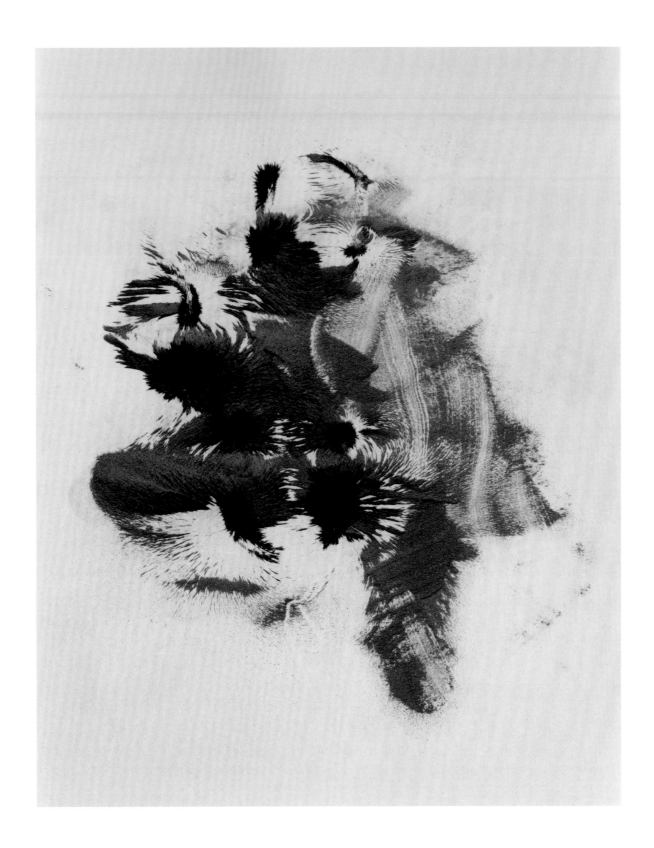

Untitled, 2012

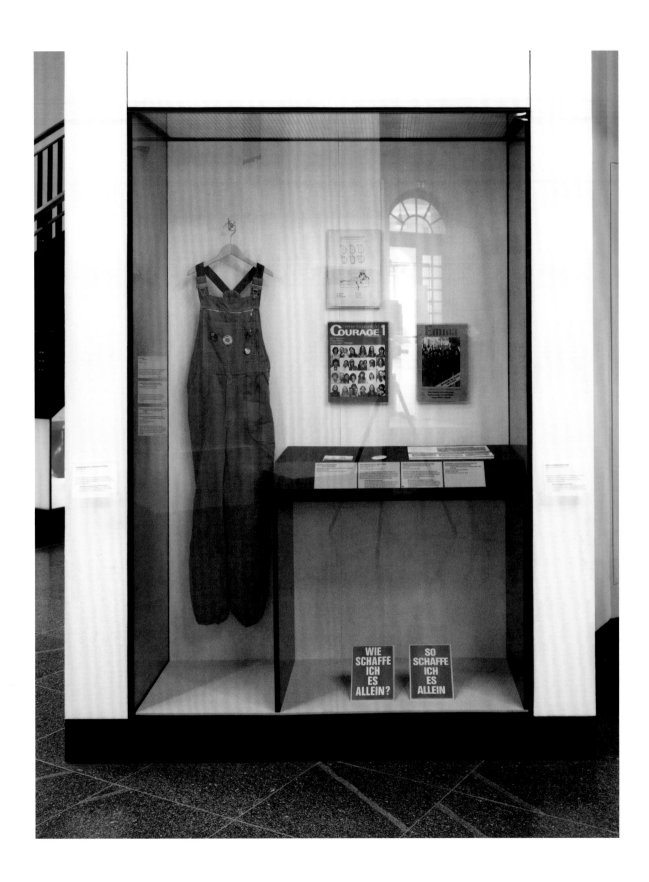

Vitrine zur Geschichte der Frauenbewegung in der Bundesrepublik Deutschland,
Deutsches Historisches Museum, Berlin, 2013

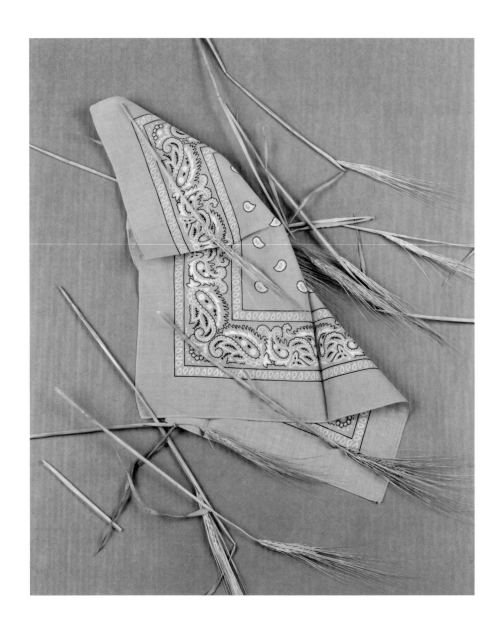

Paisley and Wheat Pink, 2013

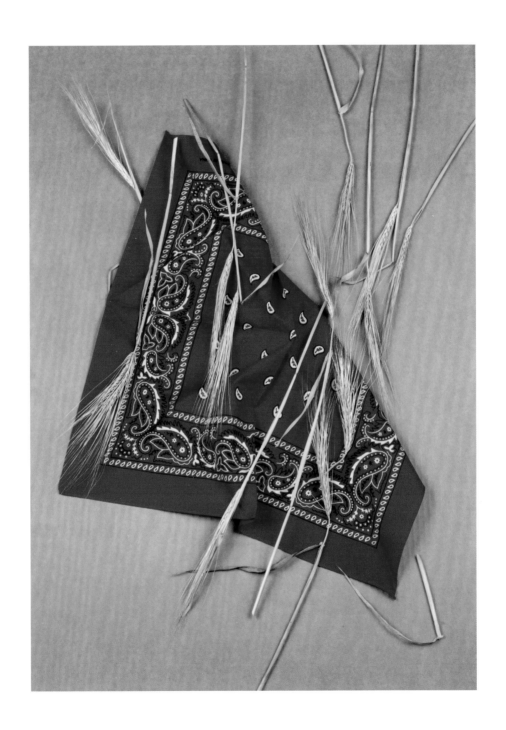

Paisley and Wheat Red, 2013

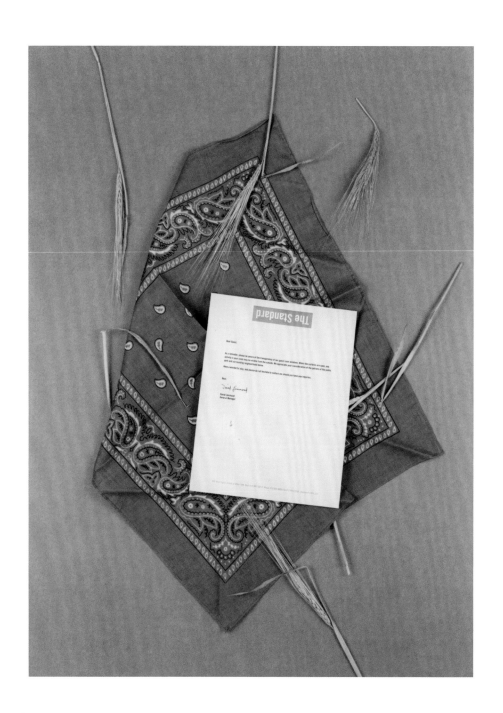

Paisley and Wheat Medium Gray, The Standard, 2013

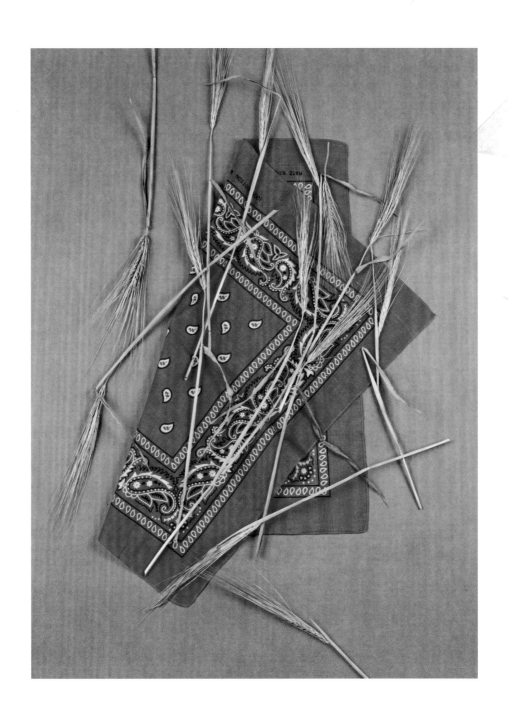

Paisley and Wheat, Orange #1, 2013

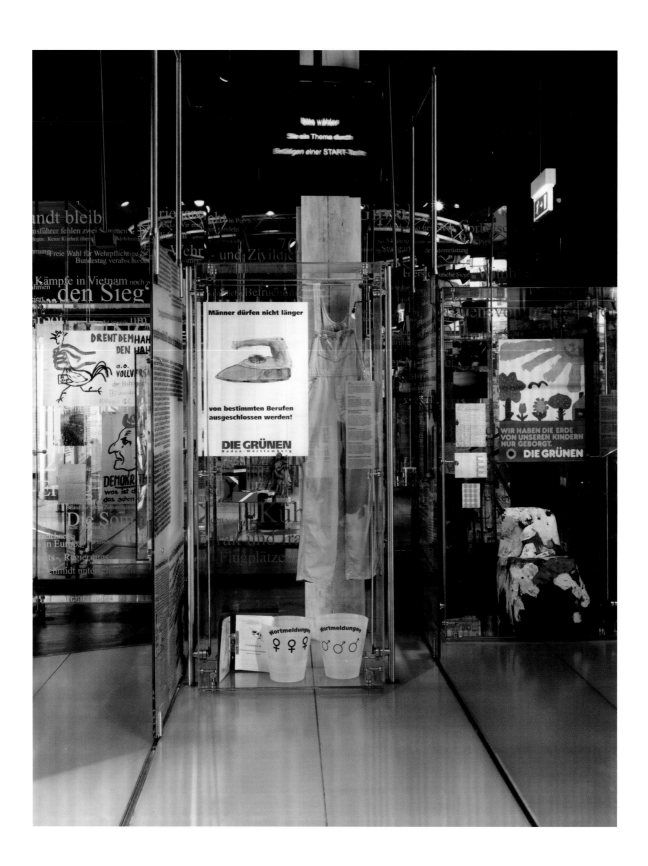

Vitrine zur Geschichte der Frauenbewegung in Baden-Württemberg,
Haus der Geschichte Baden-Württemberg, Stuttgart, 2013

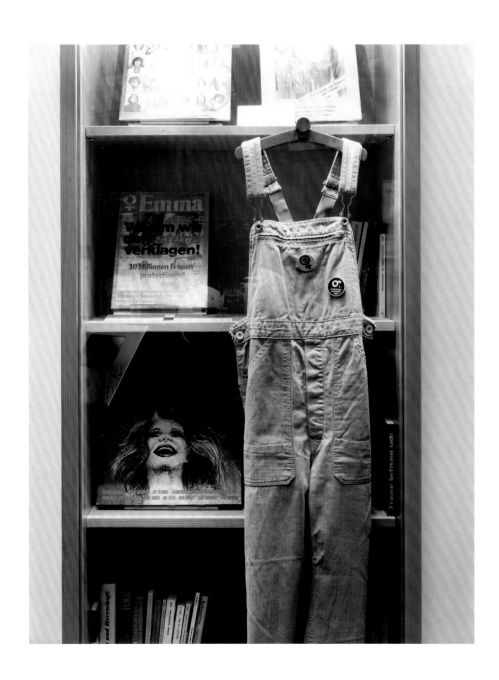

Vitrine zur Geschichte der Frauenbewegung in der Bundesrepublik Deutschland,
Stiftung Haus der Geschichte der Bundesrepublik Deutschland, Bonn, 2013

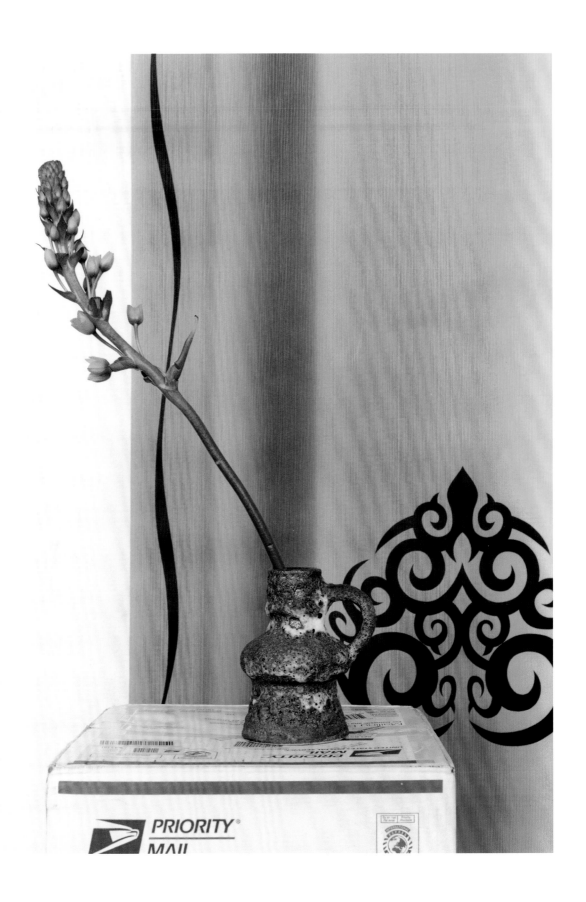

Untitled (Tribal), 2010

Sale, 2010

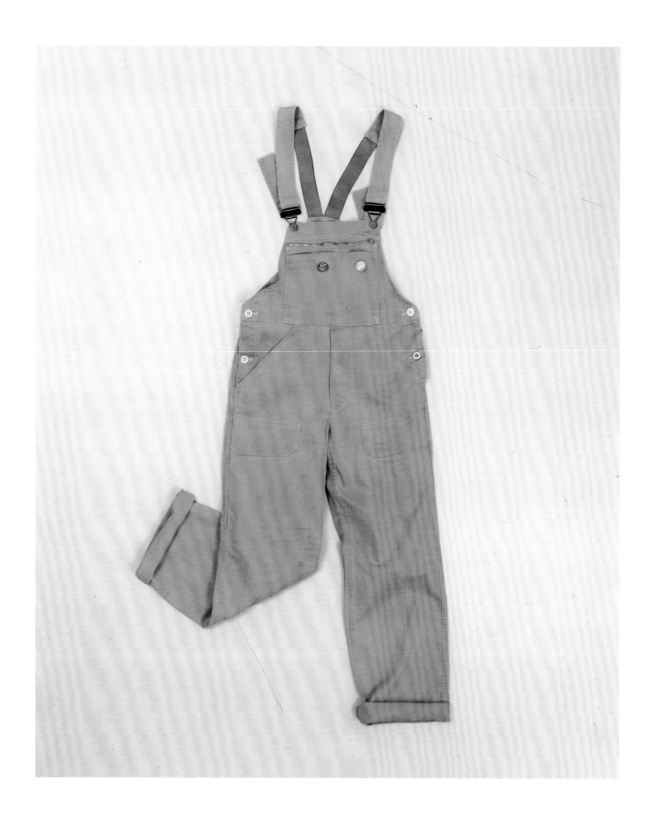

48 Latzhose 3, "Kicking Leg", 2014

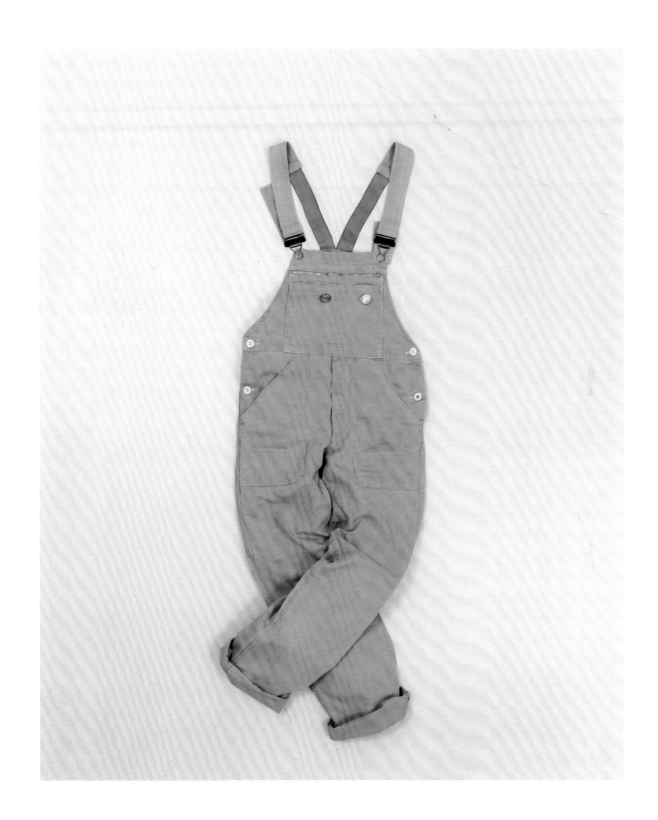

Latzhose 1, "Relaxed", 2014

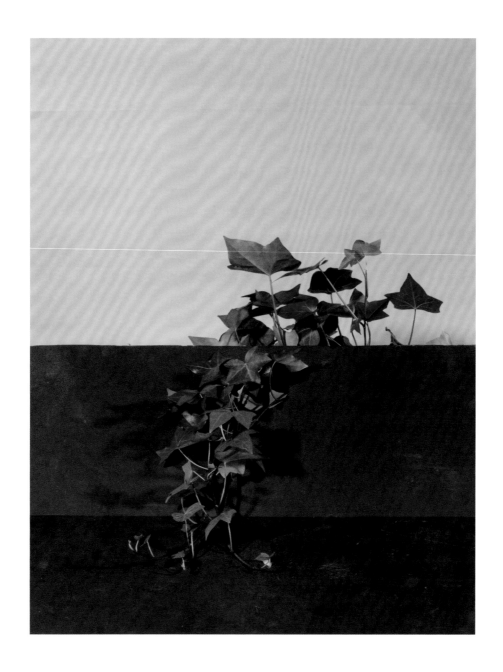

Ivy, 2013

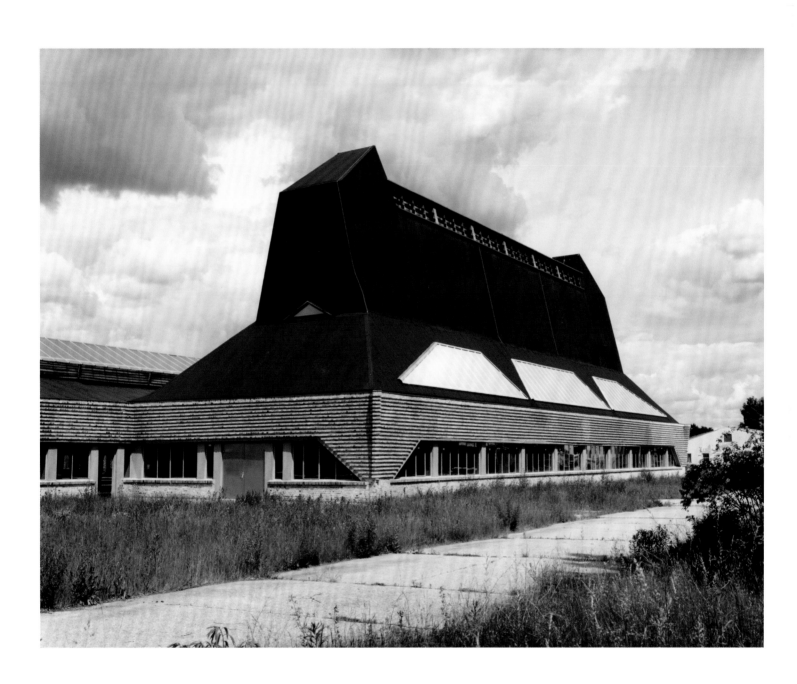

Erich Mendelsohn Hat Manufacture Building Friedrich Steinberg,
Herrmann & Co, Luckenwalde (1921–1923), 2013

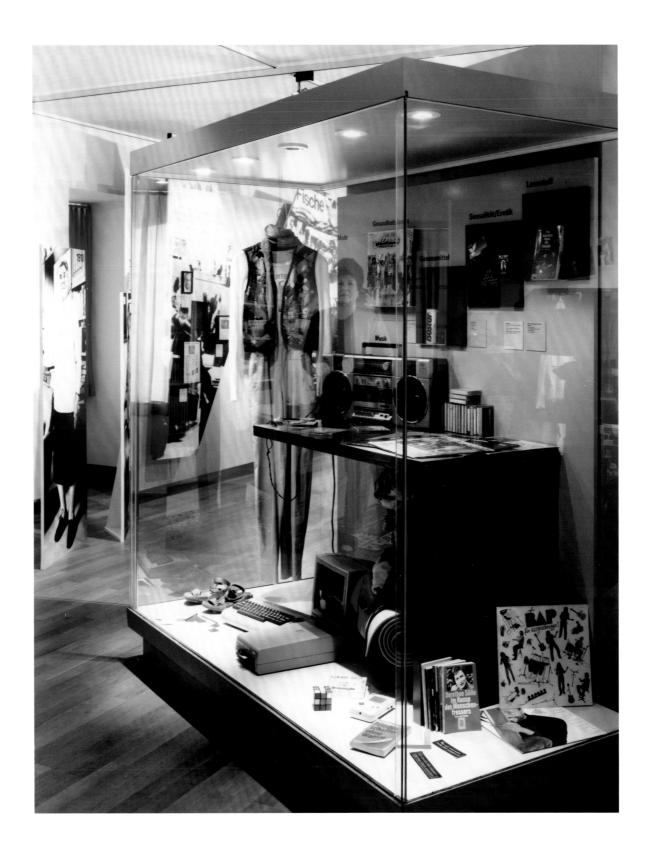

Badisches Landesmuseum Karlsruhe Vitrine „80er Jahre", Dauerausstellung, 2014

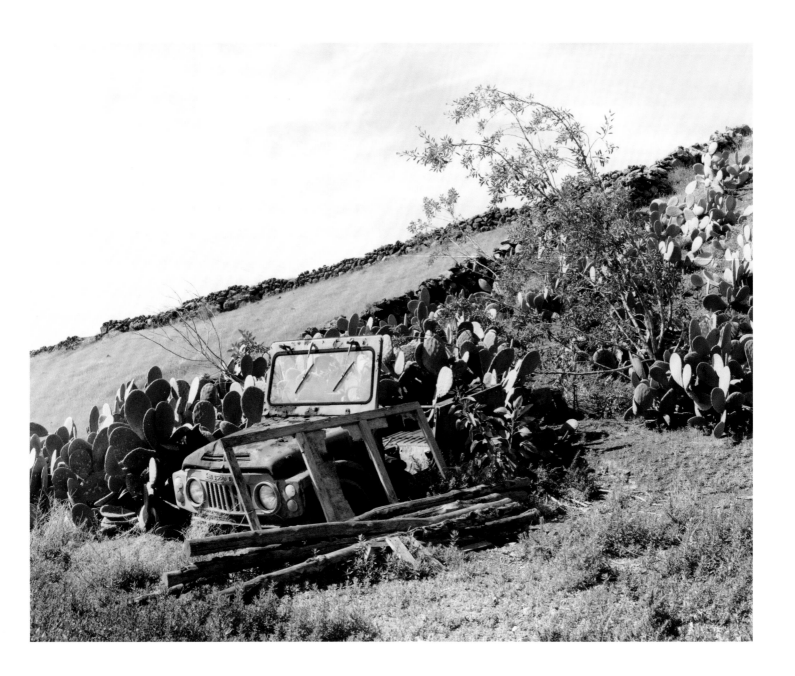

Art Car #2, 2010

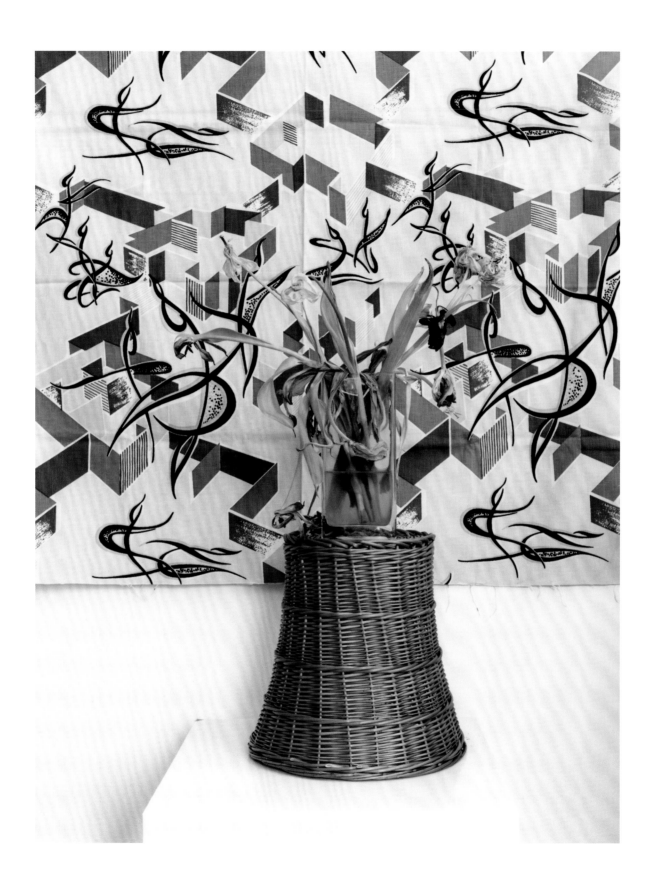

Untitled, 2011

Yellow (Paisley), 2010

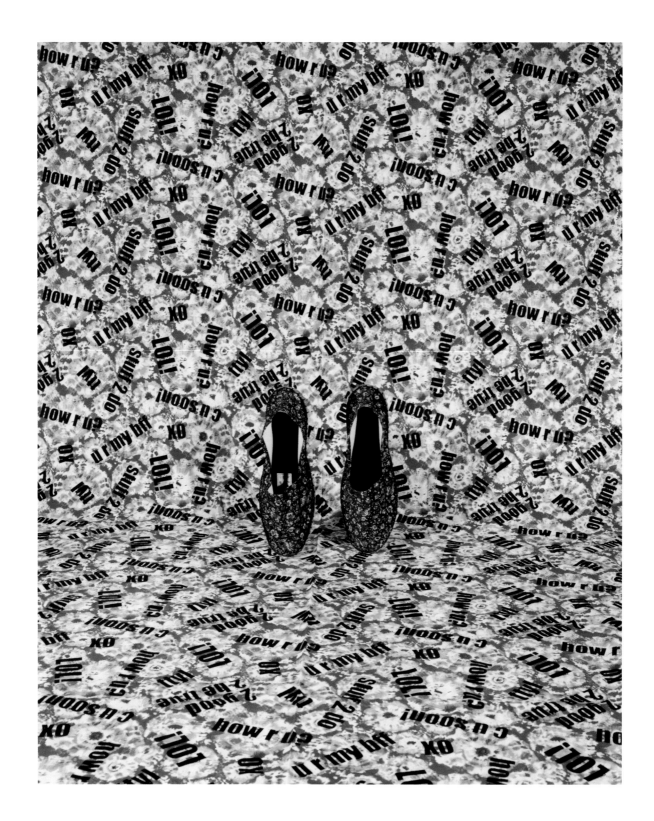

Espadrilles, U R MY BFF, LOL!, HOW R U?, 2013

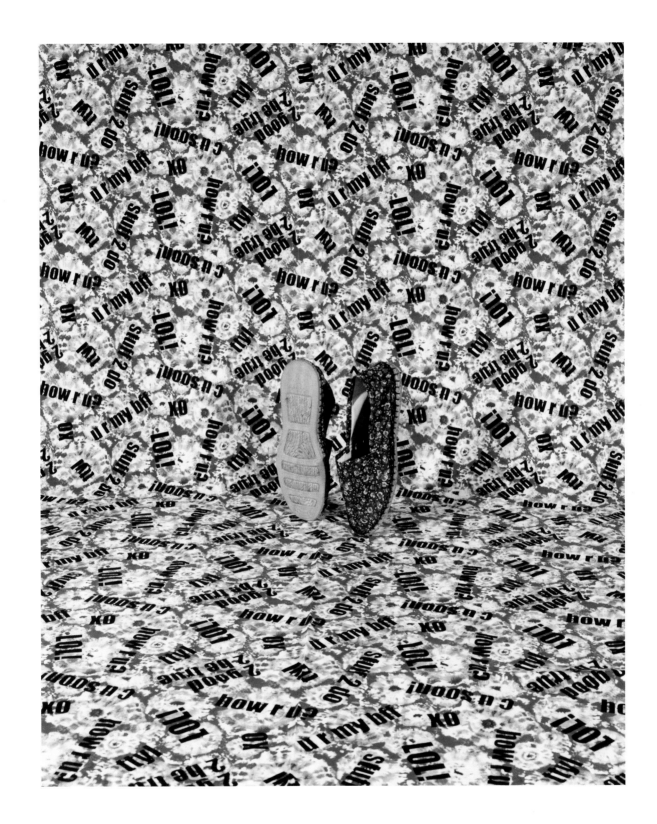

Espadrilles, 2 GOOD 2 BE TRUE, TTYL, XO, HOW R U?, 2013

Percent for Art, 2013

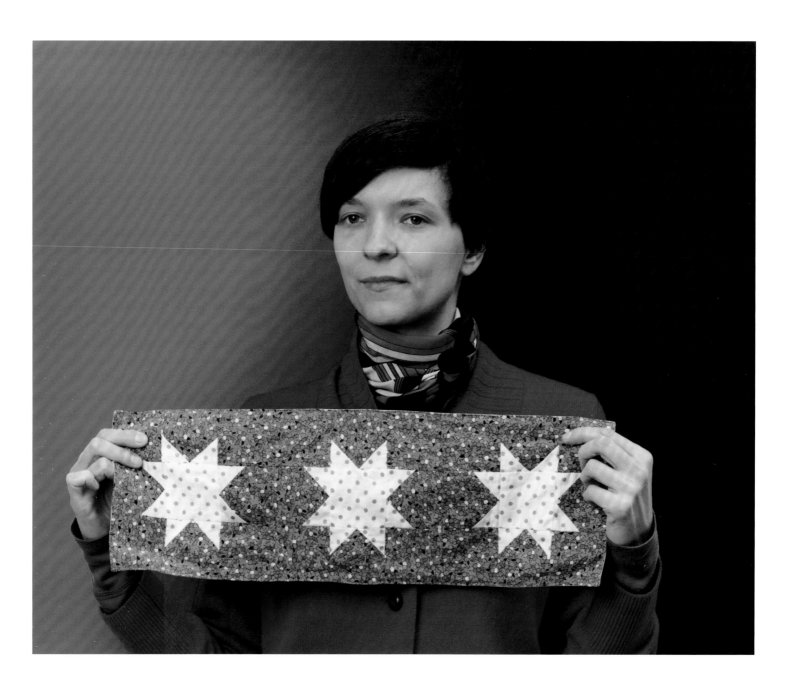

Anna #2, 2011

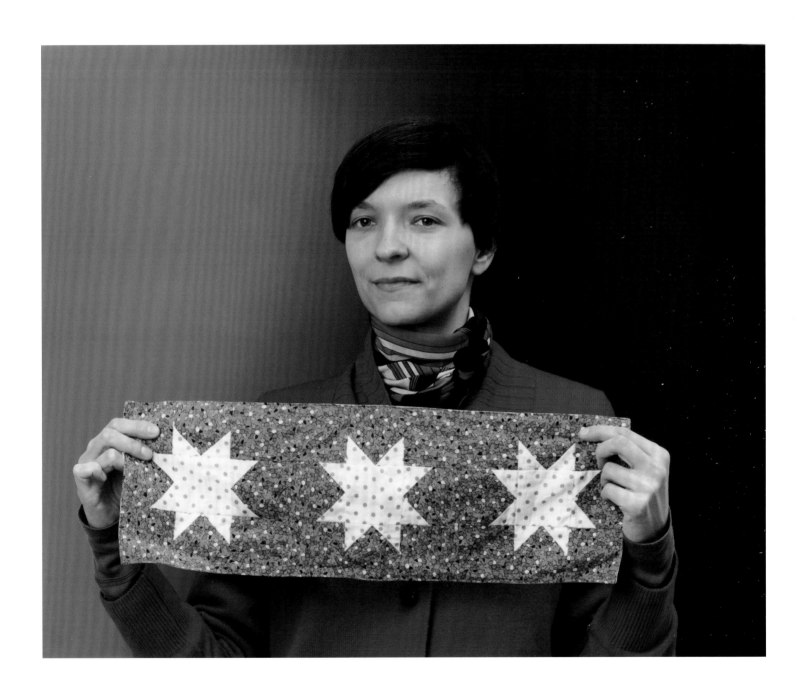

Papierzylinder, 2011

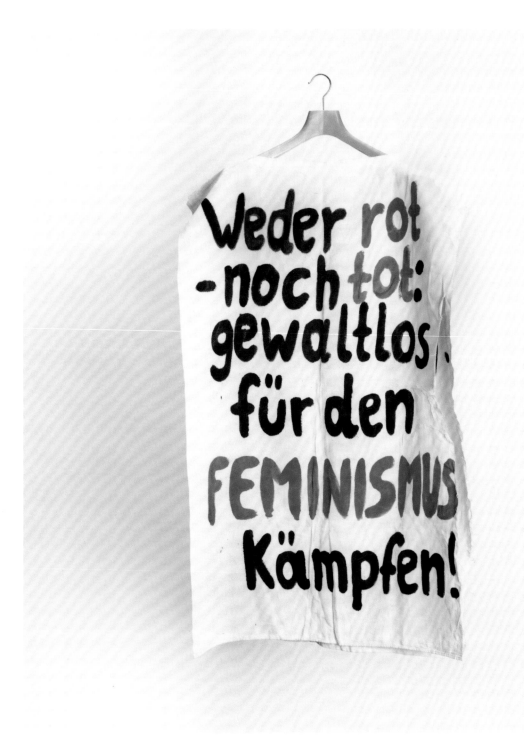

Institut für Zeitgeschichte – Archiv, Bestand Hannelore Mabry / Bayerisches Archiv
der Frauenbewegung, Signatur ED 900, Box 403 Nr. 2

Körperüberhang: „Weder rot noch tot: gewaltlos für den Feminismus kämpfen!" /
„Mit Bertha von Suttner – Die Waffen nieder! Dafür kämpft DER FEMINIST", 2014

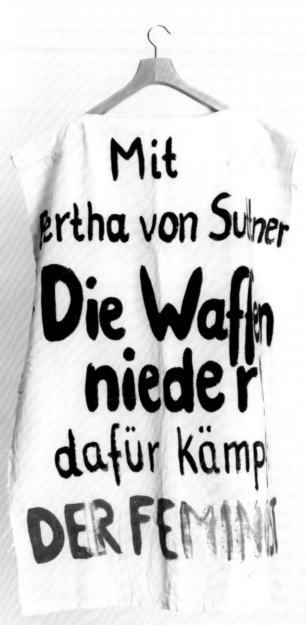

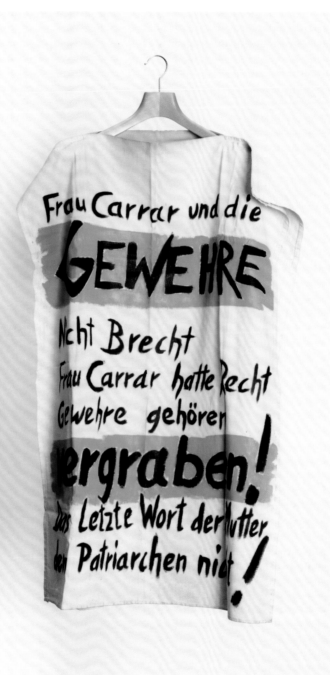

Körperüberhang: „Frau Carrar und die Gewehre – Nicht Brecht Frau Carrar hatte Recht –
Gewehre gehören vergraben! Das letzte Wort der Mutter dem Patriarchen nicht!" /
„Frau Carrar und die Gewehre – Nicht Brecht Frau Carrar hatte Recht –
Gewehre gehören vergraben! Das letzte Wort der Mutter dem Patriarchen nicht!", 2014

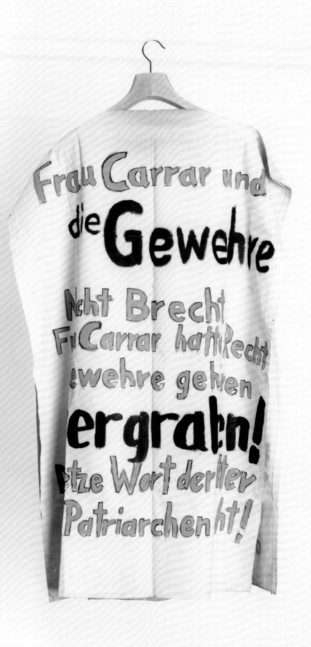

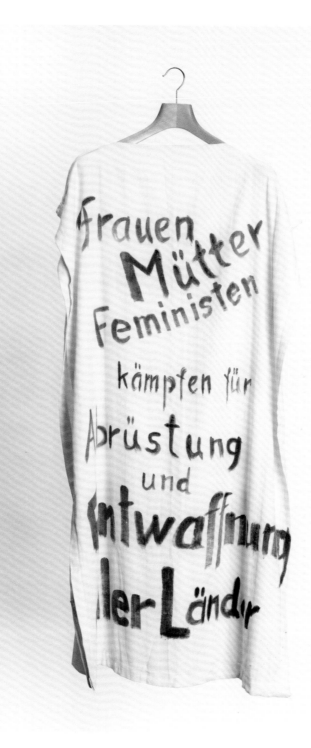

Körperüberhang: „Frauen Mütter Feministen kämpfen für Abrüstung und Entwaffnung aller Länder" /
„Wir fordern Abrüstung bis zum Küchenmesser", 2014

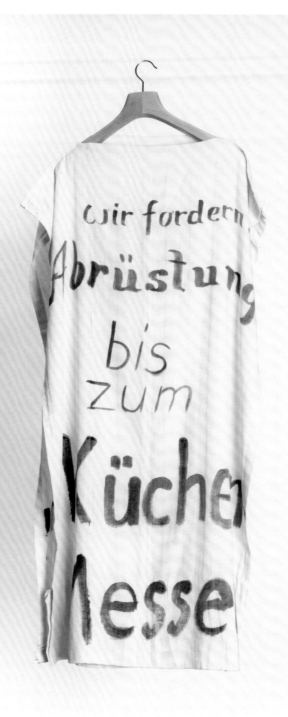

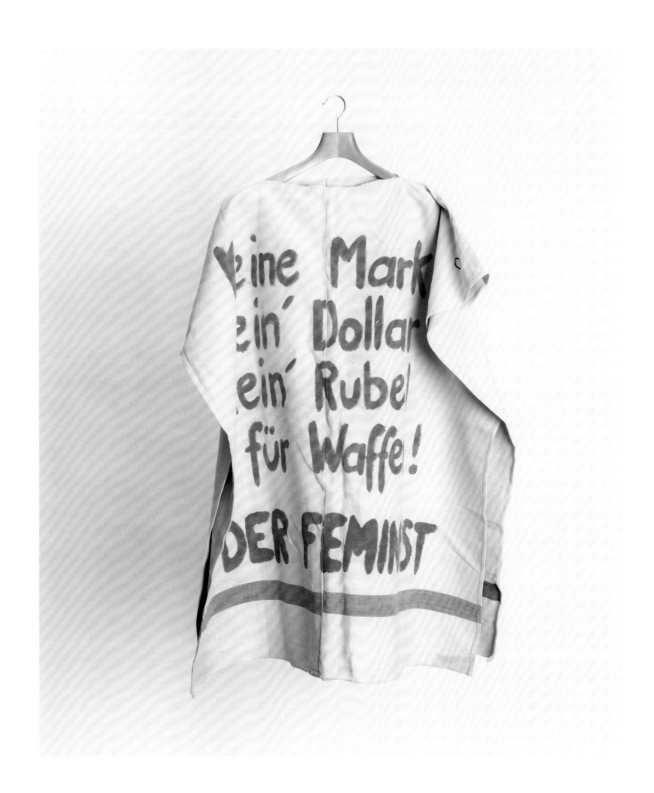

Körperüberhang: „Keine Mark, kein Dollar, kein Rubel für Waffen! DER FEMINIST" /
„Menschenrecht statt Männerrecht", 2014

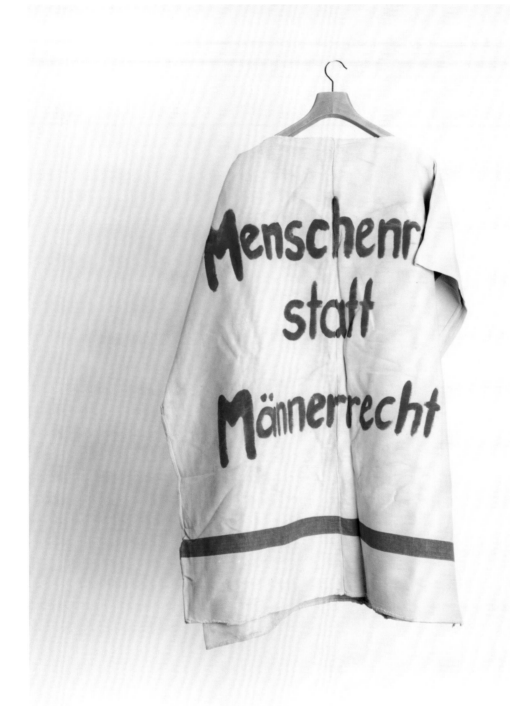

Horseshoe Magnet, 2011

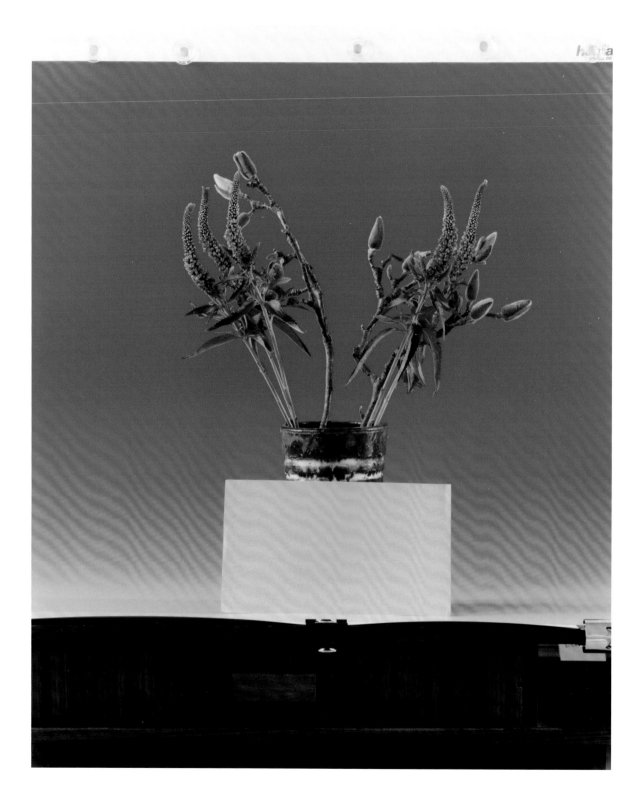

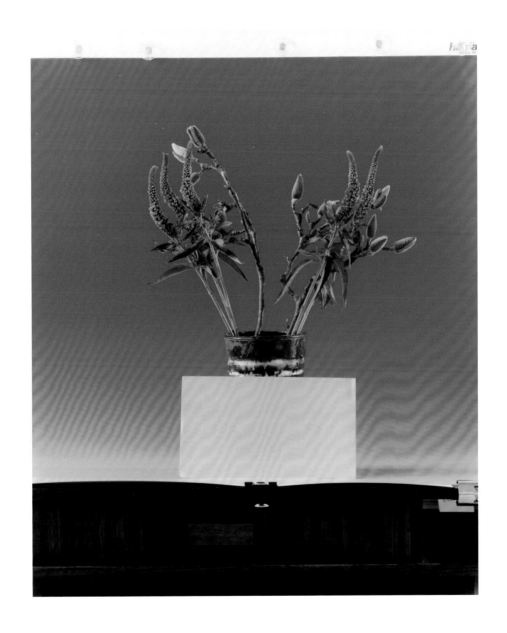

Untitled, 2013

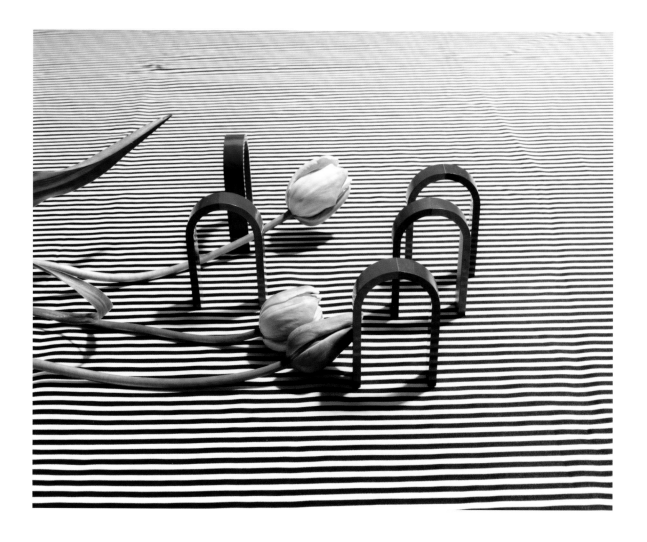

80 Untitled, 2013

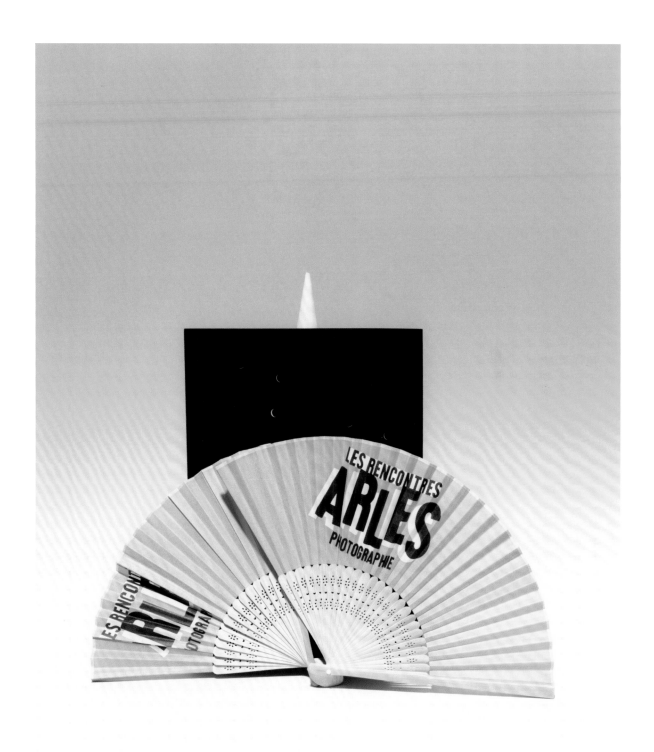

Arles, 2012

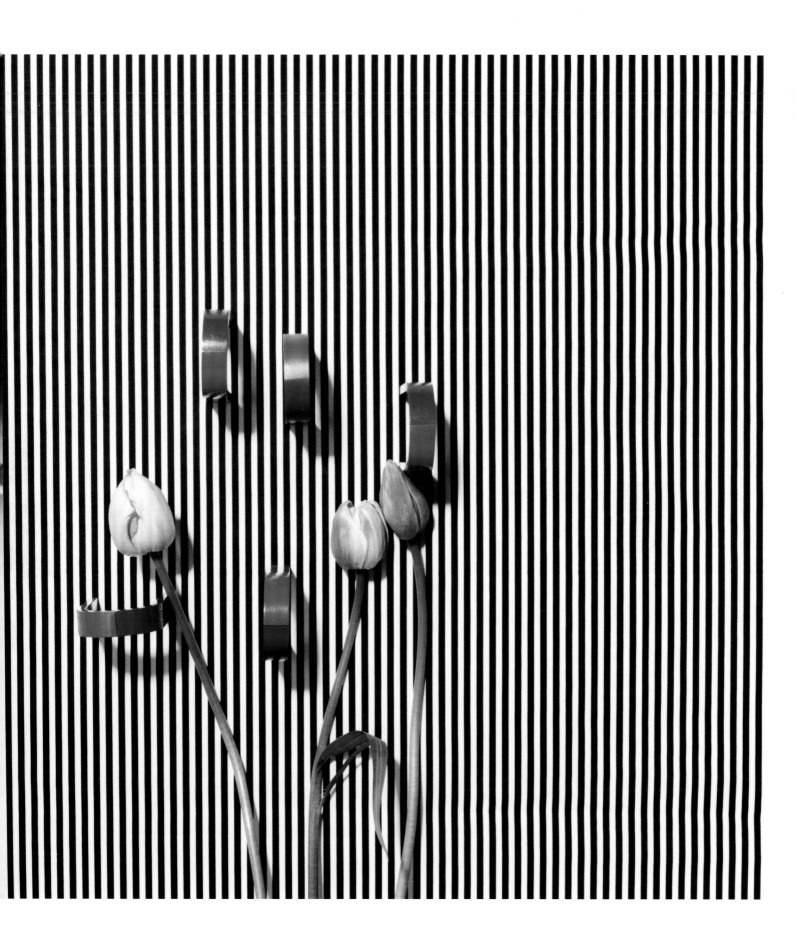

Untitled, 2013

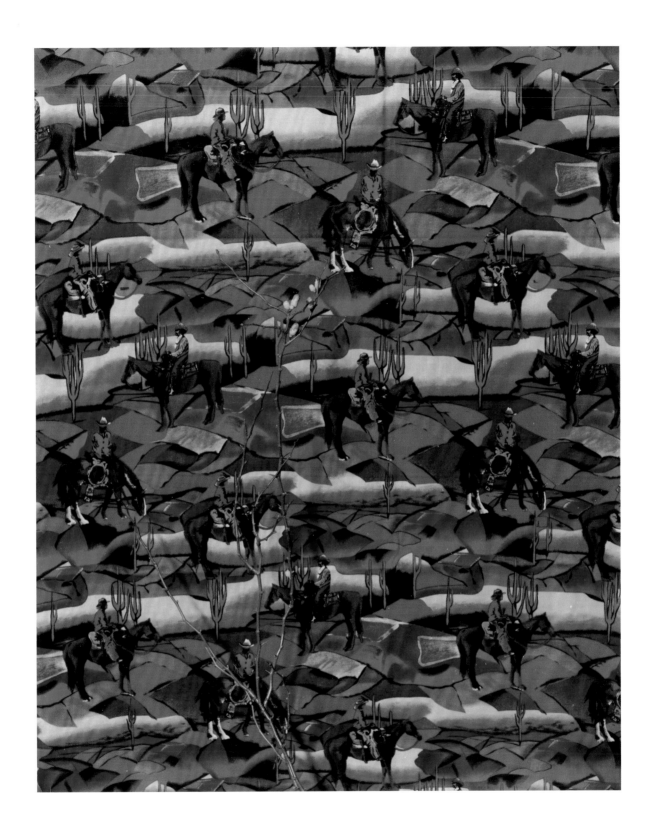

Untitled, 2011

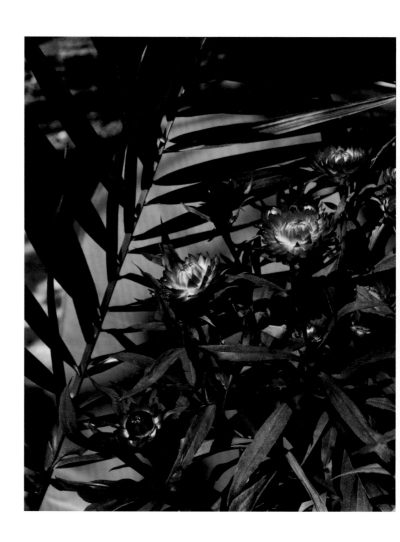

Strawflowers, 2013

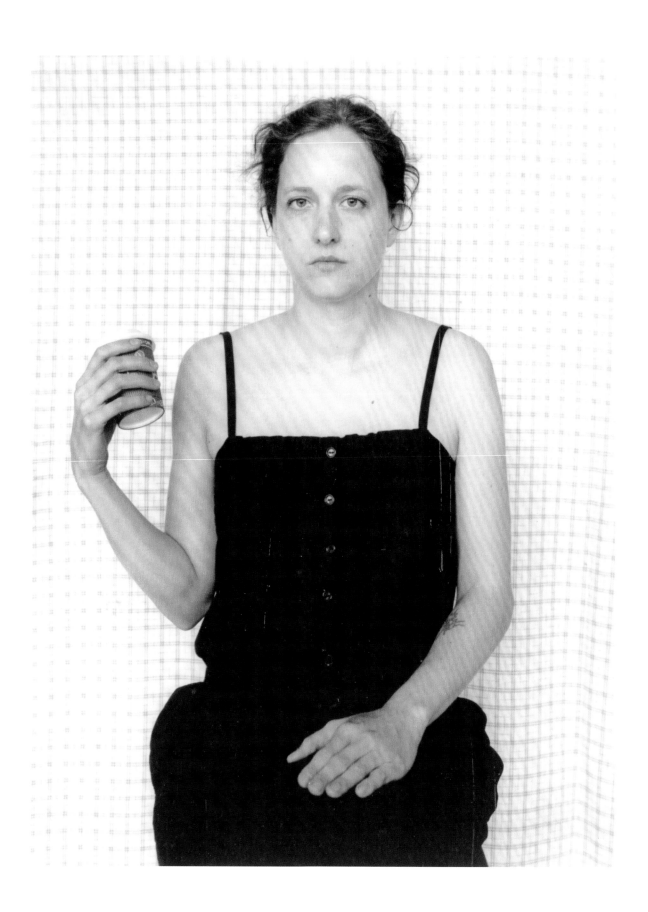

Michaela Coffee Break, 2009

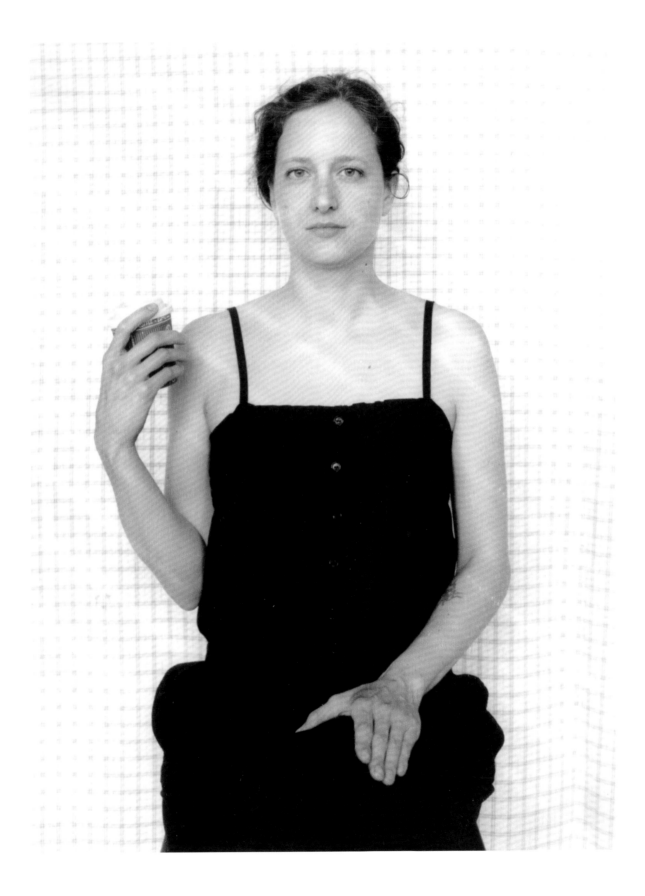

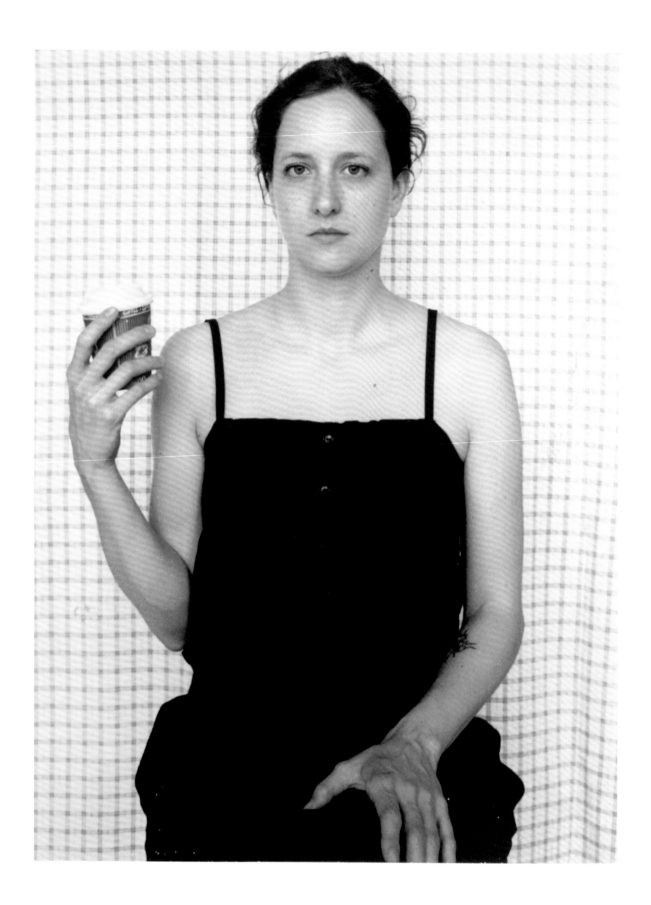

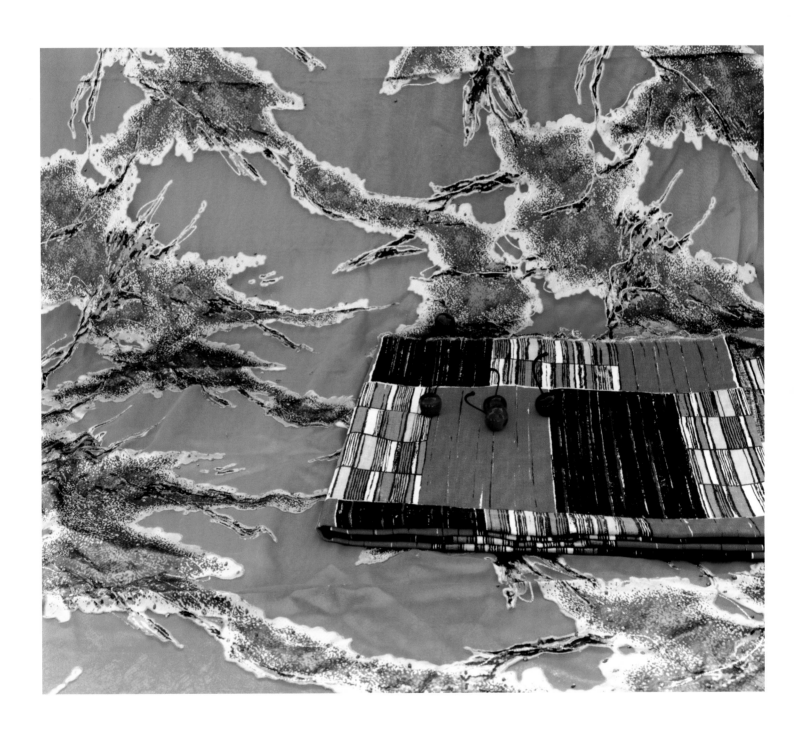

Venice, Zurich, Brussels, 2009

Dove, Kurfürstendamm, 2013

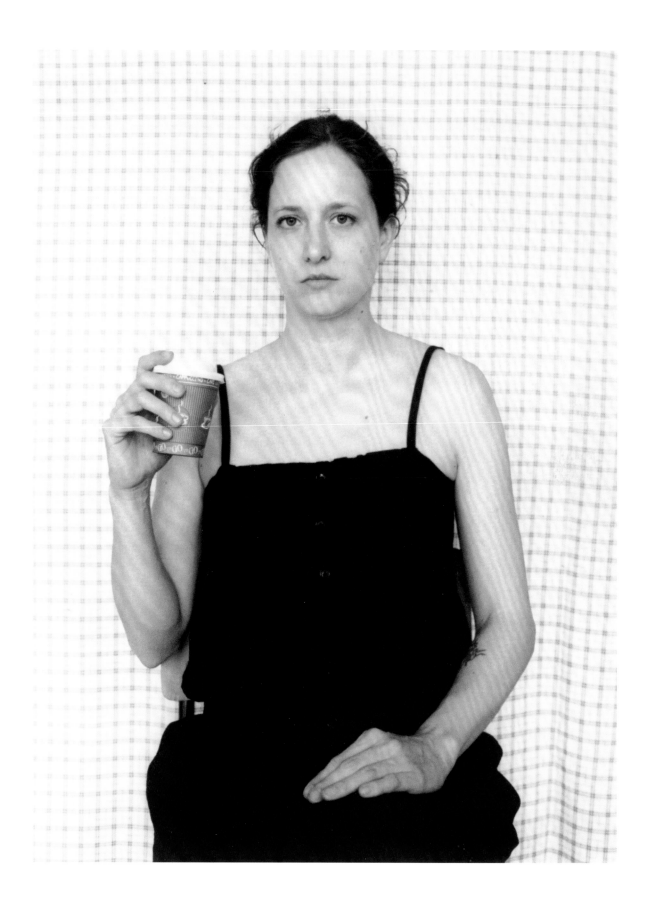

Michaela Coffee Break, 2009

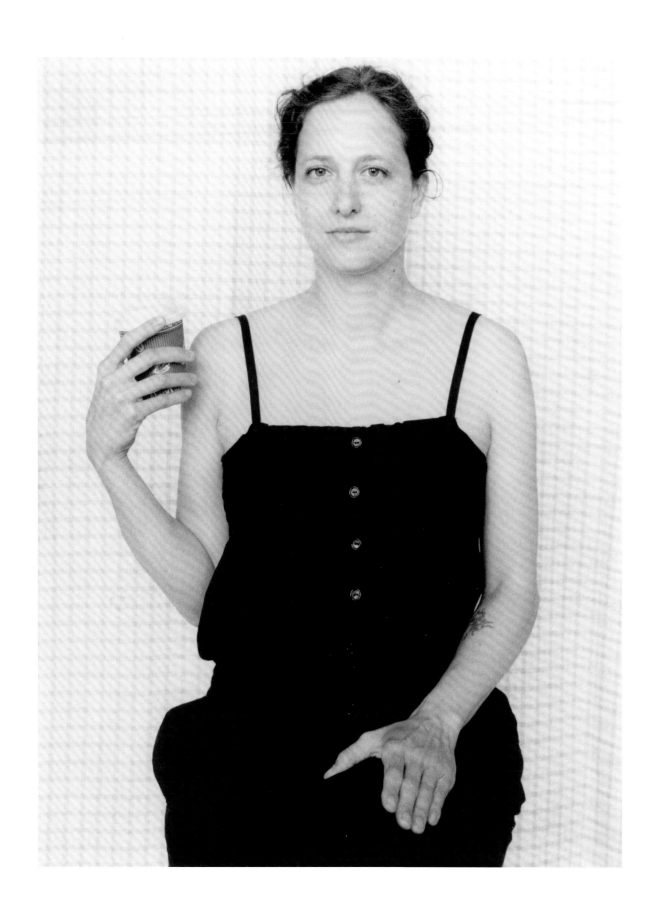

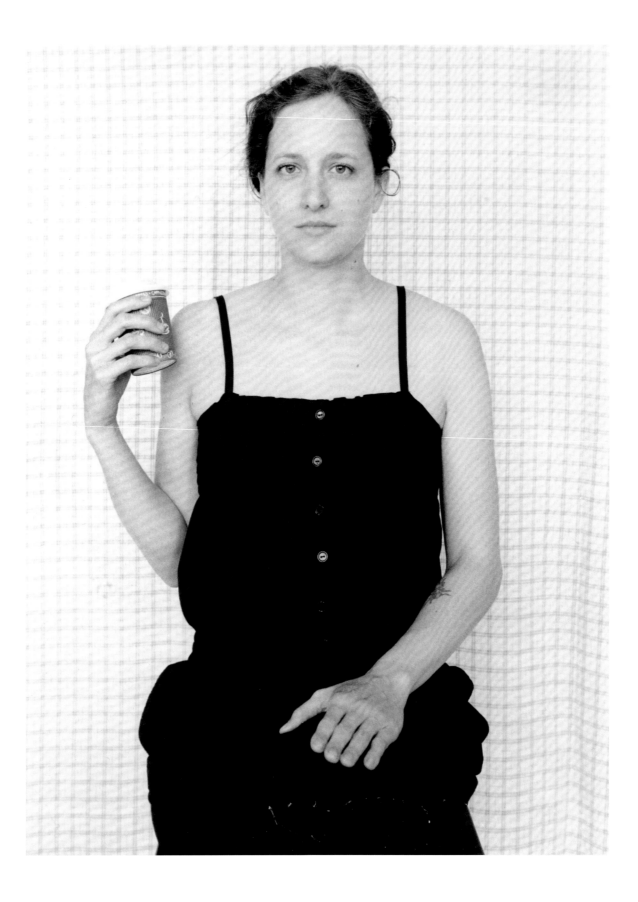

Untitled, 2012

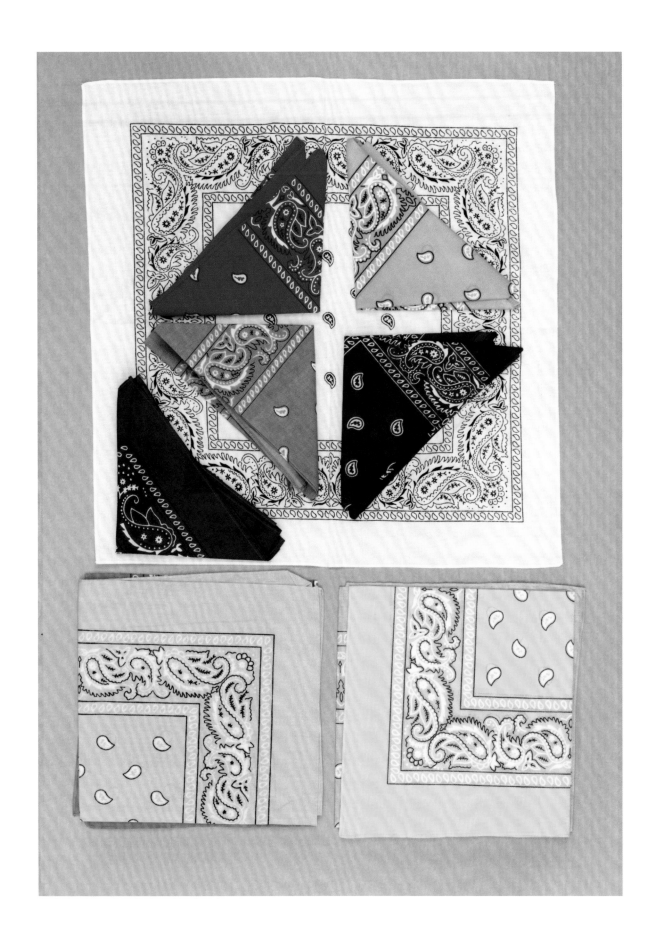

Untitled (Cardboard, Paisley, Close Up), 2013

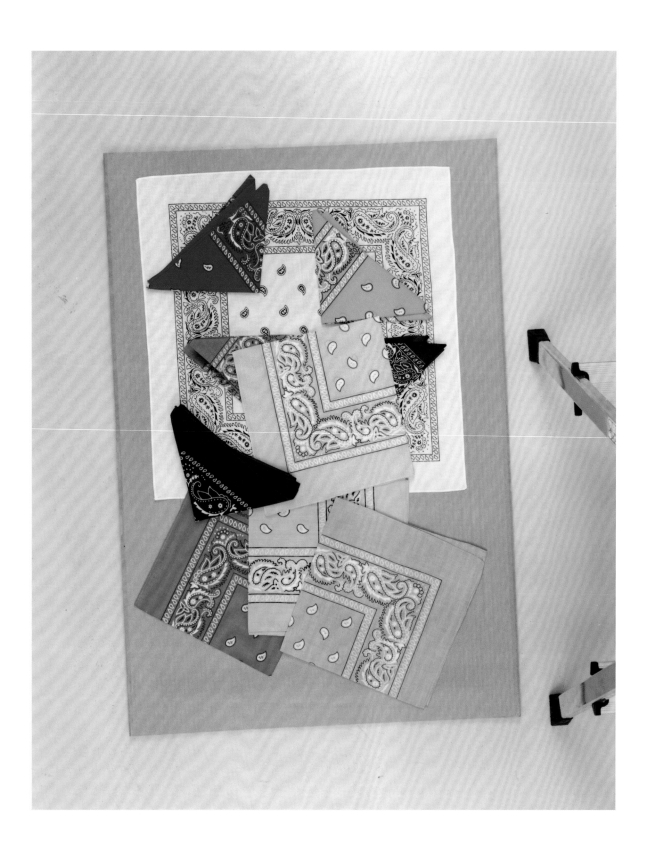

Untitled (Cardboard, Paisley, Ladder), 2013

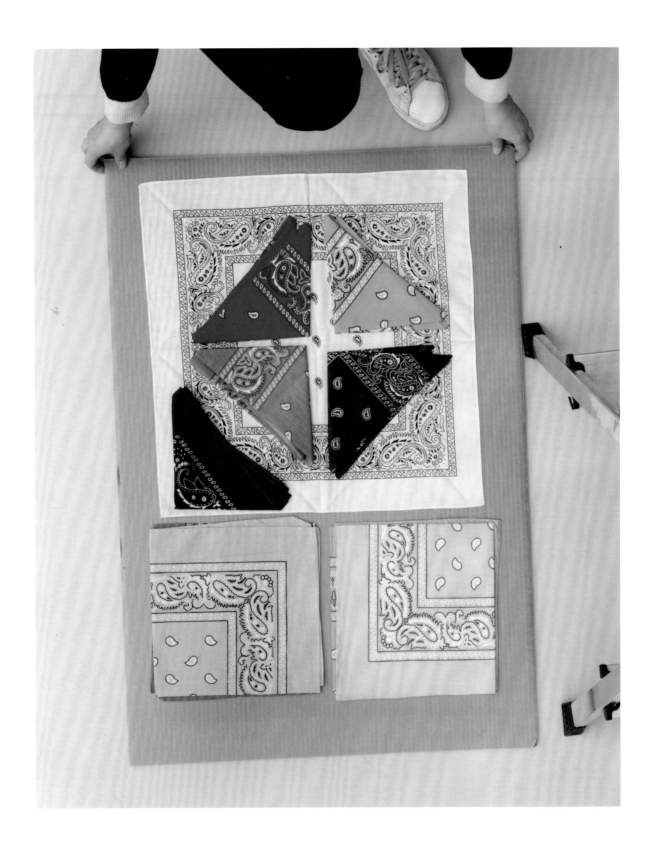

Untitled (Cardboard, Paisley, Ladder, Hands), 2013

Foreword

Annette Kelm's photographs are among the most evocative contributions to the recent history of art. Evolving over the past fifteen years, during an era of photography's rapid and ongoing reinvention as both artistic object and digital image, Kelm has succeeded in situating herself as a picture maker of unapologetic clarity. Her practice employs a comprehensive understanding of and devotion to the traditions of photographic studio practice, marked by an affiliation for analogue film and darkroom techniques, as well as a continuing interest in the pictorial genres of landscape, portraiture and still-life. With recourse to these tried and tested idioms, she has constructed a body of photographic imagery that is remarkable for its visual depth and resistance to description.

Kelm's idiosyncratic choice of subjects is typified in an ongoing series of works picturing such humble commodities as straw hats, lamps, handkerchiefs, patterned fabrics, iron filings, or t-shirts—often presented in extraordinary juxtapositions. In a thorough analysis of Kelm's practice, art historian and critic Tom McDonough suggests an underlying paradox embodied in these photographs, which appear simultaneously "factual, objective, and empirical […] or, alternatively, as deceptive, misleading, and constructed as fiction." Critic and writer Isabelle Graw, in an extensive interview with Kelm, also notes this detached, complex stance, referring to "the distanced approach, the laconic style of representation" and how her "work is not primarily about the ostensible interest of the object being photographed." In response, Kelm provides us with a startling answer: "I look for things that are as devoid of definite meaning as possible." This clue offers rich avenues of understanding into a photographic practice of which, as McDonough keenly notes, "though nothing is hidden, meaning does not reside in what is visible before us."

Presentation House Gallery and the Kölnischer Kunstverein are pleased to jointly publish this monograph on the work of Annette Kelm. The publication marks the occasion of the artist's two solo exhibitions at Presentation House Gallery, North Vancouver (September 8 to October 14, 2012), and at Kölnischer Kunstverein, Cologne (November 7 to December 21, 2014).

The Vancouver exhibition marked the first major opportunity for her work to be seen in a public gallery in North America, and both the exhibition and publication have been graciously supported by Brigitte and Henning Freybe, to whom Presentation House

Gallery is tremendously grateful. The publication has also been supported by Jane Irwin and Ross Hill, as well as Helen and John O'Brian, through their membership in Presentation House Gallery's *Publication Circle*.

The exhibition in Cologne followed Kelm's major institutional solo presentations at the Kunsthalle Zürich, the KW Institute for Contemporary Art in Berlin and the Witte de With Center for Contemporary Art in Rotterdam, focusing primarily upon the artist's production from the period between 2011 and 2014. The exhibition and the publication were both generously supported by the Kunststiftung NRW, and by its representatives Dr. Ursula Sinnreich and Dr. Barbara Könches. The Kölnischer Kunstverein is also very grateful for the comprehensive engagement of Claudia and Kurt von Storch, who have accompanied the development of the exhibition with great dedication.

On behalf of both organizations, we would also like to express thanks and appreciation to Isabelle Graw and Tom McDonough for their intelligent and thoughtful writing, to Hendrik Schwantes for the elegant graphic design of this publication, to translators Benita Goodman, Gerrit Jackson, Klaus Roth and Michael Wetzel, as well as to the Johann König and Andrew Kreps Galleries for their ongoing assistance in realizing this publication. Finally, we wish to thank Annette Kelm for her trust and for a productive collaboration.

Reid Shier
Director and Curator,
Presentation House Gallery

Moritz Wesseler
Director and Curator,
Kölnischer Kunstverein

Die Fotografien, die Annette Kelm im Laufe der letzten fünfzehn Jahre geschaffen hat und die eine große Bandbreite von Erscheinungsformen aufweisen, können zu den bereicherndsten Beiträgen der jüngeren Kunstgeschichte gezählt werden. Die Künstlerin, die in einer Zeit an die Öffentlichkeit trat, in der sich die Fotografie sowohl als künstlerisches Objekt als auch als digitales Bild kontinuierlich neu erfand, gelang es, sich als Bildermacherin von kompromissloser Klarheit zu positionieren. Ihre Praxis beruht auf einem umfassenden Verständnis und einer Leidenschaft für die Traditionen der Fotostudiopraxis, unter Einbeziehung analoger Film- und Dunkelkammerverfahren, sowie einem fortwährenden Interesse an Bildgenres wie Landschaft, Porträt und Stillleben.

Mittels dieser bewährten Ausdrucksformen hat sie eine fotografische Bilderwelt kreiert, die einerseits aufgrund ihrer visuellen Prägnanz und andererseits wegen ihres Widerstandes gegen sprachliche Beschreibungen bemerkenswert ist.

Ein typisches Beispiel für Kelms eigenwillige Themenwahl bildet eine fortlaufende Serie von Werken, die – oftmals in außergewöhnlicher Kombination – einfache Dinge abbilden wie Strohhüte, Lampen, Taschentücher, gemusterte Textilien, Eisenspäne oder T-Shirts. In einer eingehenden Analyse von Kelms Praxis verweist der Kunsthistoriker und -kritiker Tom McDonough auf ein grundlegendes Paradox, das in diesen Fotografien zum Ausdruck kommt, welche gleichzeitig „[…] als faktentreu, objektiv, empirisch […] oder, ganz gegensätzlich, als trügerisch, irreführend, als Fiktion konstruiert" zu sein scheinen. Die Kritikerin und Autorin Isabelle Graw stellt in ihrem ausführlichen Interview mit Kelm ebenfalls diese distanzierte Haltung fest, „diese Distanziertheit, das Lakonische der Darstellung", und die Tatsache, dass es in ihrem Werk „[…] nicht in erster Linie um die vermeintliche Interessantheit des fotografierten Objekts" geht. Als Erwiderung darauf macht Kelm eine verblüffende Aussage: „Ich suche nach Dingen, die so weitgehend wie möglich entleert sind." Dies ist ein Hinweis, der vielfältige Zugänge zum Verständnis einer fotografischen Praxis anbietet, in der, wie McDonough scharfsinnig bemerkt, „nichts verborgen bleibt, […] der Sinn des Bildes [jedoch] nicht in dem zu finden [ist], was uns vor Augen steht".

Die Presentation House Gallery und der Kölnische Kunstverein freuen sich, gemeinsam die Monografie über das Werk von Annette Kelm herauszugeben. Die vorliegende Publikation erscheint anlässlich der beiden Einzelausstellungen der Künstlerin in der Presentation House Gallery, North Vancouver (8.9.–14.10.2012), und im Kölnischen Kunstverein, Köln (7.11.–21.12.2014).

Die Ausstellung in Vancouver bot die erste umfassende Möglichkeit, Kelms Werk in einer öffentlichen Institution in Nordamerika zu sehen. Dabei wurden die Ausstellung und die Publikation durch die großzügige Unterstützung von Brigitte und Henning Freybe möglich, denen die Presentation House Gallery zu größtem Dank verpflichtet ist. Darüber hinaus leisteten auch Jane Irwin und Ross Hill sowie Helen und John O'Brian durch ihre Mitgliedschaft im *Publication Circle* der Presentation House Gallery einen wesentlichen Beitrag zur Realisierung des Katalogs.

Die Präsentation in Köln hatte demgegenüber einen etwas anderen Hintergrund und knüpfte in gewisser Hinsicht an die institutionellen Einzelausstellungen von Annette Kelm in der Kunsthalle Zürich, im KW Institute for Contemporary Art in Berlin sowie im Witte de With Center for Contemporary Art in Rotterdam an und konzentrierte sich hauptsächlich auf die Arbeiten der Künstlerin aus dem Zeitraum von 2011 bis 2014. Sowohl die Ausstellung als auch der Katalog wurden dabei von der Kunststiftung NRW und deren Vertreterinnen Dr. Ursula Sinnreich und Dr. Barbara Könches großzügig unterstützt. Zudem ist der Kölnische Kunstverein sehr dankbar für das Engagement von Claudia und Kurt von Storch, die den Entstehungsprozess der Ausstellung mit großer Leidenschaft begleitet haben.

Neben den jeweils speziell mit Vancouver und Köln verbundenen Förderern haben zu dem Gelingen der Ausstellungen sowie des Kataloges eine ganze Reihe von weiteren Personen einen entscheidenden Beitrag geleistet, denen wir an dieser Stelle unseren Dank sowie unsere Anerkennung aussprechen möchten: Isabelle Graw und Tom McDonough für ihre intelligenten und tiefgründigen Beiträge, Hendrik Schwantes für die elegante grafische Gestaltung dieser Publikation, den Übersetzern Benita Goodman, Gerrit Jackson, Klaus Roth und Michael Wetzel und ebenso der Galerie Johann König und der Andrew Kreps Gallery für deren beständige Hilfe bei der Verwirklichung dieses Buches. Schließlich wollen wir auch Annette Kelm für ihr Vertrauen und die produktive Zusammenarbeit danken.

Reid Shier
Direktor und Kurator der
Presentation House Gallery

Moritz Wesseler
Direktor und Kurator des
Kölnischen Kunstvereins

Photography and Its Other

A conversation with Isabelle Graw
and Annette Kelm

Isabelle Graw As I was preparing for our conversation, I asked myself what the source of your work's strength is. My intuition is that, although it's photography, it makes overtures to other media—mostly painting and film. The art historian David Joselit recently gave a lecture about how painting had externalized itself from the 1990s on, how it was beside itself, as it were. I think the same could be said about your photographic images—they have learned the lessons of other forms of art, and that is the source of their strength. Interestingly, this invigorating effect of externalization was already described in the nineteenth century by Baudelaire, in an essay on Delacroix. He wrote: "Every form of art strives to take the other's place and borrow new strength from it." It's my impression that your work borrows new strength primarily from painting. It's symptomatic, for example, that you always print your pictures by hand so that the mechanical process of photography is confronted with a painterly and "handmade" aspect.

Annette Kelm It's important to me to control the entire process of production, starting with the shot, which, unlike other artists, I also take myself rather than delegating it to others. I personally stand behind the camera and do the lighting, so I also do part of the work in the lab. I go there to test the sizes and colors. It's important to me to retain this level of control over the process of production. That's also why I still work with analogue cameras, especially since I haven't been able to find a laboratory in Berlin that would let me continue to work the way I can with analogue photography. When I started studying at the art academy, my goal was actually to do oil painting, but somehow that didn't really work out. Collecting was more my thing—making many pictures and then selecting from among them. I liked that photography let me make lots of decisions, even after a picture was taken. But I think it's always tricky to regard photography as painting or to compare it to painting. If I wanted to do painting, I would paint; or I could produce sculptures, and, in fact, I did paint and produce sculptures as well for a long time—like the welded sculptures at the Jugendhaus. I can certainly imagine that I'll do something other than photography one day. On the other hand, photography is a passion of mine, as is this process of manual craftsmanship, which is extremely important to me.

Isabelle Graw I wouldn't want to equate photography to painting, but perhaps painting is nonetheless one of the implicit horizons of your art? I'm thinking, for example, of the way fabrics figure in your work. To use textiles nowadays means first and foremost to invoke a painterly tradition, the tradition of the fabric painting—from Hans Arp to Sigmar Polke and on to Cosima von Bonin. Then there's the fact that the fabrics bring external meanings into your works—the person who designed them; the history of the fabric's origin, such as the colonial origin of a particular pattern; the association of textiles with the female sphere of reproduction; a certain texture that resembles the surface of a painting; the way they tap into the realm of applied and decorative arts; etc., etc. But what's interesting is that the photographic medium ultimately triumphs over these references in your pictures. For example, there's no tactile experience of the fabrics, which are subordinated to the physical presence of photography and its smooth surface. We might say that the way you photograph neutralizes these fabrics and keeps them at bay. As though the diverse references to the world of real life implicit in them were kept in check and brought under control by a sober photographic aesthetic. The complex of fabric painting is brought into play, but then subordinated to the conditions of the photographic medium.

Annette Kelm I'm not at all aware of such a subordination; if it happens, it's incidental. Photography is very important to me, or, more precisely, the context of a work in photography. When I started using these fabrics, it was for the simple reason that I had no money at the time, being a student, and photography backdrops would just have been much more expensive. So I used more affordable fabrics, and, strangely enough, these dull, cheap textiles always turn out looking best. I've also made a habit of bringing back some fabric or other from my travels. Whenever I have a show somewhere, for example, I collect fabrics and bring them back to my studio, where they gather until I am ready to use them.

Isabelle Graw And what's so fascinating to you about these fabrics? Is it the colors? The textiles are a major source of strong colors in your visual language.

Annette Kelm Color is definitely part of it.

Isabelle Graw Are the patterns what captivate you?

Annette Kelm Not so much. The structure, I'd say.

Isabelle Graw Do you also use fabrics because they're traditionally associated with the female sphere and bring things like fashion, which is to say, a field of applied art, into play?

Annette Kelm Perhaps, but I'm less interested in the association with femininity than in the impression of physical presence fabric creates. My preference for patterns is surely also an upshot of

my childhood in the 1970s, when everything was patterned. From the wallpapers …

Isabelle Graw … to the bedding.

Annette Kelm I vaguely remember horses—my bedding had brown horses on it and my brother's had brown soccer shoes. By the way, I think it's odd that photography is still being segregated—like when people organize pure photography exhibitions, for example. There's also this weird art photography scene, which is stewing in its own juice. That's never been especially interesting to me.

Isabelle Graw Perhaps photography is being singled out in this way because it's still a fairly young medium?

Annette Kelm Maybe—but then, video art is even younger and is rarely ever shown in dedicated exhibitions. And the same goes for installation art, which is never presented in isolation and segregated from other media.

Isabelle Graw But doesn't the art world tend to work with a pluralistic conception of media anyway and present different media formats side by side in one exhibition or regard them as elements of one and the same artistic practice?

Annette Kelm Yes. But there are nonetheless artists like Martin Parr, whose work is shown in purely photographic contexts. Similarly, work by artists such as William Eggleston or Stephen Shore is rarely on display with pieces by other artists. That's why I've always been glad that my art has tended to circulate in contexts where it doesn't matter very much whether you make photographs or work in other media.

Isabelle Graw Still, I think that photography has looked to painting for orientation from the very beginning. The sociologist Raymonde Moulin has proposed an interesting hypothesis in this regard. Even early photography in the nineteenth century, she argues, emulated painting in order to gain recognition as art. By imposing limits on the number of prints, for example, photographers imitated the ideal of the unique work in painting.

Annette Kelm And the idea extends further. For example, when artists like Andreas Gursky established photography in the museum, they did so by emulating the dimensions of the painted panel. That wasn't even so long ago.

Isabelle Graw Then again, we could also describe photography as a medium that denotes reality, as Roland Barthes has aptly put it. It's a consequence of the indexical quality of its signifiers that photography can be experienced as a trace of the world we live in—it suggests a physical connection to reality, which seems to be present even though it remains absent. Interestingly, the theme of traces plays a central part in your work—I'm thinking, for example, of the picture of a horse's hooves in the snow (*Untitled,* 2001). The hooves are visible, but they've also left prints in the snow. Moreover, the horse's body casts a shadow that's experienced as a trace as well.

Annette Kelm That's a kind of question I find hard to answer. I don't like to let myself be pinned down when it comes to the content of my work. Because that creates the danger of people always focusing on a particular aspect I might have mentioned, and I would rather

not restrict the scope of my work's meaning. There's something fundamentally problematic, I think, about an artist interpreting or explaining her work.

Isabelle Graw I really just wanted to know whether the theme of the trace might be of interest to you, because the photograph, too, can be read as the trace of something. The same theme echoes in a more recent series of pictures showing iron filings moved by a magnet (*Untitled,* 2012). We see the trace of the horseshoe-shaped magnet as well as the traces of its magnetism—the form, that is to say, of the iron filings arranged by it in particular constellations.

Annette Kelm Originally, I had photographed the magnets and made still lifes out of them. I had ordered them online from a school supplies store—these were complete classroom sets, including iron filings. They strongly reminded me of physics experiments back in the day, so I started experimenting. On the one hand, I scattered the filings as though haphazardly, and on the other hand, I made tiny and, you might say, painterly interventions to generate certain configurations.

Isabelle Graw The result looks like an imprint of a cat's fur.

Annette Kelm Yes, there's something fur-like about it.

Isabelle Graw But the palm tree series (*I Love the Little Baby Giant Panda, I'd Welcome One to My Veranda,* 2003) seems to be about the theme of traces as well—the palm fronds turn with the wind; they indicate its direction, are moved by it, physically connected to it, thus making it present in its absence.

Annette Kelm I actually took these pictures on Mallorca one night during a storm. It was a bit like a studio shooting, since I knew that, if I was going to use my flash on these palm trees, the backdrop would be black. I wanted to have the sequence of a palm passing through various stages generated by the wind. It's certainly true that with photography, people always impute a reference to reality right away. They want to know exactly: what was that? With painting, they're far less inquisitive. There's also the fact, of course, that there's an issue with the image rights when I take a photograph of something. If I were to paint a copy, no one would likely care very much for the question of image rights. But the moment I take a photograph of something, people make the comparison with reality, although it's really only our reality—the world as seen through the eyes of a human being. As a dog, I would perceive it very differently.

Isabelle Graw (laughs) But it seems to me that you also take preventive measures to stop people from homing in right away on the question of the reality depicted in a photograph. For example, you've left the large majority of your pictures untitled, which curbs people's associations. In the picture of the *Seiler Meteorit Piano 116,* I was also struck by the distanced approach, the laconic style of representation. It's immediately understood that it's not just about this object, that we shouldn't be interested only in its history. Unlike many artists who bank on the significance of their objects, your work is not primarily about the ostensible interest of the object being photographed.

Annette Kelm That's certainly true. I try to find objects, fabrics, or even people that allow for a sort of openness in terms of meaning that I can then use for my purposes. I look for things that are as devoid of definite meaning as possible. Although symbolism is often unavoidable—and symbols are everywhere—I try to push back against the symbolism so the beholder perceives the object a photograph depicts not just as a symbol, but as this particular object and, at the same time, as something that can be abstracted from. The decision to leave a picture untitled, too, is usually motivated by my desire to keep things as indeterminate as possible, to keep the picture open. In the past, I often chose concrete titles, such as *After Lunch Trying to Build Railway Ties.* That's the title of a eucalyptus branch I shot before a piece of fabric. The reference is to Los Angeles, where the picture was taken; they used to plant eucalyptus trees there to make railway ties out of them. But it didn't work because the wood was far too soft. I similarly felt like I was trying to do something that didn't work. So it's more of a poetic title that renders a mood.

Isabelle Graw On the one hand, photography encourages people to focus on the object. On the other hand, your work counteracts this tendency—with its aesthetic of dispassionate distance, for example. That's your signature style, we might say, which, in the final analysis, seems to be more important than what a given picture depicts.

Annette Kelm I don't really know how to respond to that.

Isabelle Graw I'm thinking, for example, of the series of baseball caps, some of which are pretty colorful (*Caps,* 2008).

Annette Kelm But they show little of my hand: I photographed them in a very neutral style, as though making pictures for a mail order catalogue, in lateral and three-quarter views …

Isabelle Graw True—that lends them a sober, matter-of-fact appeal. Only, some of the caps are of almost expressive vitality because of their colorful bands, which break up the cool studio aesthetic a bit.

Annette Kelm Perhaps I'm too deeply immersed in my work. I try to photograph certain things as neutrally as possible and really attempt to keep out of it for the most part. My most neutral works are the photographs I took of fabrics by Dorothy Draper—they're really just repros. Anyone could have made the same pictures.

Isabelle Graw Isn't this very neutrality your signature style? And then it was you who chose certain fabrics as well as a particular detail and angle.

Annette Kelm But these are minimal decisions. Of course you always have to select the detail, or the camera you're using to make the picture, or the size of the print you're going to exhibit.

Isabelle Graw Another factor is that the ornamentation of the fabrics counteracts the neutrality you strive for. I think your large prints, such as *Big Print #5* (2007), are the most painterly of your works and, I might say, the wildest ones—even if they also evince, at once, an aspect of distancing and somehow look cold, maybe due to the cool light.

Annette Kelm I often simply avoid having shadows. Shadows set a strange mood—there's something photographic and homey about any play with light and shadow that I don't like too much. That's also why many photographers aren't fond of my work, because it's too un-photographic for their taste. Light and shadow is a fundamental theme in photography—and, in my work, it doesn't play much of a role.

Isabelle Graw What exactly is your problem with shadows?

Annette Kelm That they always bring so much atmosphere into a picture. The result is a sort of idealization. If I were to take a picture of an egg, with a long shadow, as in a Bauhaus photograph, and then also have the shadow be refracted in a glass, the effect would be too theatrical for me. It's difficult enough to take pictures of objects and keep their symbolism out. Once I also imagine the shadow the object casts, it becomes something different entirely.

Isabelle Graw It becomes too expressive for your taste?

Annette Kelm Exactly.

Isabelle Graw But there are also series, like the pictures of the lamp slowly falling over (*Untitled,* 2010), in which you concede a sort of expression to the object you depict—it looks like it has agency. The lamp seems to fall over of its own accord, as though seized by an intrinsic dynamic.

Annette Kelm But barely so. One might stage these pictures with much more drama. A lamp that's actually falling over looks very different. I'd tied the lamp to a nylon cord and let it down piece by piece. So that series involved a sort of trick. I also often have a hard time deciding in favor of a single picture, which is why I'll have several shots and I also like having a series. It expands and enlarges the image of the object.

Isabelle Graw It unfolds and pluralizes it.

Annette Kelm That's also what photography makes possible—that you can make endless numbers of pictures and then do with them as you like.

Isabelle Graw With the lamp falling over, and in your serial works more generally, two things are happening at once: time is being frozen while its progress is being shown. That's quite literally the case in *Anonymous, Lilac Clock Bag Buffalo Exchange* (2007), a picture of a pocket watch. Time seems to have been effaced from the picture (the object having neither time nor space and stripped of any context), but then the passing of time is immediately suggested by the motion of the watch hand. These pictures have a filmic feel, comparable to Muybridge's motion studies …

Annette Kelm Photography also invariably has to do with time. You have to choose a shutter speed for every shot you take—aperture and speed, those are the constants of photography, also in the darkroom. It's always about aperture and speed.

Isabelle Graw Could you explain that in more detail?

Annette Kelm The aperture is the opening of an analogue camera, and you adjust its size as needed. For example, when you take a very small aperture—22—the picture will be fairly sharp. With 5.6, you may see that the eyes of a sitter, say, are sharp while the rest of the portrait is blurry. And that's always in proportion to time.

Isabelle Graw Time determines the outcome, and yet your pictures look as though time had stopped in them.

Annette Kelm And that's how it is. It's a small moment that you'll never be able to reproduce.

Isabelle Graw We might speak of an absence of context in your works, because they show isolated objects abruptly lifted out of their environment. There's also the cool presentation. The portraits of friends, however, work differently—in these pictures you seem to be trying to define your standpoint, as it were, as though parading your social life.

Annette Kelm No, that's not the point at all. The reason I make portraits of friends is fairly pragmatic—I would simply feel awkward standing in my studio with a stranger, someone I'm not comfortable with. Working with analogue cameras is a pretty intricate process and sometimes also rather time-consuming. So I prefer it when I know and like the person whose portrait I'm making. With the portrait of Michaela Meise (*Michaela Coffee Break,* 2009), we'd been out for a drink and I'd noticed that she would look completely different from one minute to the next, that the expression of her face would suddenly change completely. I wanted to capture that. But my goal with these pictures is certainly not to record my place within a scene—on the contrary: I've usually chosen my sitters with a view to visual aspects. I come up with many of my ideas in everyday life. As we're sitting here and talking, for example, I see that bottle there and imagine it in a particular light. So I think about things and they're on my mind, and then at some point everything's just right and I can bring it all together.

Isabelle Graw Does that mean that your portraits of friends have nothing to do with the network art many critics now talk about, which is about visualizing the artist's own social networks?

Annette Kelm Yes, and I would find it totally embarrassing if they did; that's an approach I've always steered clear of, from the very beginning. I don't like that line of work at all. And the people who appear in my pictures are complete unknowns in many of the contexts in which my pictures are being shown—in Japan, for example.

Isabelle Graw Let's take your portrait of Julian Göthe—a series of three pictures entitled *Julian, Italian Restaurant* (2008). His eye seems to jump around from picture to picture. The series resembles an investigation into his micro-gestures and minimal movements. But he's not being examined as a representative of a type, and in contrast with, say, August Sander's approach, we learn nothing about his background, his work, his social position.

Annette Kelm First of all, I'm very fond of Julian—he's a good friend. I like his distinctive glasses, and he often wears polo shirts, which I also like. And then I knew that he would be into trying this sort of theatrical staging with me. We improvised the scene in front of this brick wall at my studio, with a tablecloth by Dorothy Draper on the table. I'd purchased it on eBay and wanted to reenact a sort of restaurant scene. The picture also borrows from a portrait of Greta Garbo by Horst P. Horst. So we reenacted this scene. I wanted a series, not just one picture.

Isabelle Graw So the individual pictures were taken at very short intervals?

Annette Kelm In portraiture, you have to take lots of pictures anyway, because the sitter will often close his or her eyes, etc. With objects, I sometimes need to take no more than two or three shots, then it's in the can; with portraits, I may need up to two or three rolls of film. But they're not real portraits in the sense of "making a portrait of this person." The way I deal with the people is more like I'm using them as objects.

Isabelle Graw The people look object-like, that's true. Are you trying to visualize the fact that, living in a celebrity culture, we have to present ourselves as quasi-objects, that we become objects?

Annette Kelm That's not what I'm trying to do at all.

Isabelle Graw But why do you photograph people as though they were objects?

Annette Kelm I'm just not interested in bringing the sitter's soul to light. There are other photographers who are better at that. I'm interested in how my photographs relate to photography in general and to portrait photography in particular. I'm trying to abstract from the person, to show something like personhood as such.

Isabelle Graw So your aim is to give more emphasis to the general within the individual?

Annette Kelm Yes—I want to show something that's universal.

Isabelle Graw With that said, might it be fruitful to compare your portrait photographs to Thomas Ruff's early photographic portraiture? He was similarly uninterested in character or soul; his focus was on how a certain social universe, a certain cultural atmosphere shaped the individual.

Annette Kelm Yes, only Ruff works with a much more rigorous experimental arrangement. All portraits are similar. My pictures are, on the whole, a little more playful. My basic attitude or approach may be the same, but then I get a bit bored when I imagine that I'm to stick to one principle and implement it with twenty people. I always also integrate other elements and then bring these different aspects together, trying to mix them.

Isabelle Graw There's a work by you—*Turning into a Parrot* (2003)— that shows a parrot and raises the issue of the artist's Oedipal relation to his or her artistic heroes. Even with the Impressionists, the parrot was emblematic of imitation in art: you work to become yourself as you emulate your heroes, but you also parrot them.

Annette Kelm You never make something out of thin air.

Isabelle Graw And yet you take up hopelessly overdetermined motifs, like the bouquet theme in *Untitled* (2012), variations on which have appeared in works by artists from Bas Jan Ader to Christopher Williams and de Rijke/de Rooij.

Annette Kelm I think it's actually a good idea to take up overdetermined motifs, in a way that brings them back to their meaninglessness or banality. Flowers, after all, are pretty banal. Where a lot has been done is exactly where you have the chance to make something of your own.

Fotografie und ihr Anderes

Ein Gespräch zwischen Isabelle Graw und Annette Kelm

Isabelle Graw Ich habe mich im Vorfeld unseres Gespräches gefragt, woraus deine Arbeit ihre Kraft bezieht. Meine Intuition diesbezüglich lautet, dass sie zwar Fotografie ist, sich aber zu anderen Medien hin öffnet – allen voran zu Malerei und Film. Der Kunsthistoriker David Joselit hat kürzlich in einem Vortrag davon gesprochen, dass sich die Malerei seit den 1990er Jahren externalisiert habe, dass sie gleichsam aus sich herausgetreten sei. Einen solchen Befund könnte man meines Erachtens auch für deine fotografischen Bilder erheben – sie haben die Lektionen anderer Kunstformen in sich aufgenommen und beziehen daraus ihre Kraft. Interessanterweise hat Baudelaire eine solche Kräftigung qua Externalisierung schon im 19. Jahrhundert in einem Text über Delacroix diagnostiziert. Er sagte: „Jede Kunstform strebt danach, den Platz der anderen einzunehmen und sich neue Kräfte von ihr zu leihen." Mein Eindruck ist nun, dass sich deine Arbeit vor allem von der Malerei neue Kräfte borgt. Symptomatisch dafür ist zum Beispiel, dass du immer Handabzüge machst, wodurch der mechanische Prozess der Fotografie mit einem malerischen Moment des „Handmade" konfrontiert wird.

Annette Kelm Mir ist es wichtig, den ganzen Produktionsprozess zu kontrollieren, angefangen von der Aufnahme, die ich ja im Unterschied zu anderen Künstlern auch selbst mache und nicht an andere delegiere. Ich stehe selbst hinter der Kamera, mache das Licht und eben auch einen Teil der Laborarbeit. Dort stelle ich Größentests und Farbtests her. Es ist mir wichtig, diese Kontrolle über den Produktionsprozess zu haben. Deshalb arbeite ich auch immer noch analog, zumal ich in Berlin bislang kein Labor gefunden habe, bei dem ich so weiter arbeiten könnte, wie es mir analog möglich ist. Als ich an der Kunstakademie angefangen habe, zu studieren, wollte ich eigentlich in Öl malen, aber das hat irgendwie nicht richtig funktioniert. Mir lag das Sammeln mehr – viele Bilder machen und unter ihnen eine Auswahl treffen. Mir gefiel, dass es in der Fotografie zahlreiche Entscheidungsmöglichkeiten gibt, auch noch im Anschluss an die Aufnahme. Ich finde es allerdings immer schwierig, Fotografie als Malerei anzusehen oder mit Malerei zu vergleichen. Würde ich Malerei machen wollen, dann würde ich malen, oder Skulpturen produzieren, und ich habe lange gemalt und auch Skulpturen produziert, etwa geschweißte Skulpturen im Jugendhaus. Ich kann mir durchaus vorstellen, irgendwann einmal etwas anderes zu machen als Fotografie. Andererseits ist die Fotografie auch eine Leidenschaft von mir, wie auch dieser handwerkliche Prozess, der mir extrem wichtig ist.

Isabelle Graw Ich würde Fotografie auch nicht mit Malerei gleichsetzen wollen, aber vielleicht ist die Malerei doch einer der impliziten Horizonte deiner Arbeit? Ich denke hier zum Beispiel an die Art und Weise, wie Stoffe in deinen Arbeiten figurieren. Heute Textilien zu verwenden, bedeutet zunächst einmal, eine malerische Tradition aufzurufen, nämlich das Stoffbild – von Hans Arp über Sigmar Polke zu Cosima von Bonin. Hinzu kommt, dass mit den Textilien externe Bedeutungen in deine Arbeiten eintreten – die Person, die sie entworfen hat, die Herkunftsgeschichte des Stoffes, etwa der koloniale Hintergrund eines bestimmten Musters, die Assoziation von Textilien mit der reproduktiven, weiblichen Sphäre, eine bestimmte Textur, die einer malerischen Oberfläche gleicht, der Bereich des Angewandten und Dekorativen, der angezapft wird, et cetera, et cetera. Interessant ist jedoch, dass das fotografische Medium über diese Bezüge in deinen Bildern am Ende triumphiert. So werden die Textilien beispielsweise nicht taktil erfahrbar, sondern der Materialität der Fotografie, ihrer glatten Oberfläche untergeordnet. Man könnte sagen, dass die Art und Weise, wie du fotografierst, diese Textilien neutralisiert und auf Distanz hält. So als würde die Aufladung der Textilien mit vielfältigen Lebensbezügen durch eine nüchterne fotografische Ästhetik in Schach gehalten und unter Kontrolle gebracht. Der Komplex Stoffbild kommt ins Spiel, wird aber den Bedingungen des fotografischen Mediums untergeordnet.

Annette Kelm Eine solche Unterordnung ist mir aber keinesfalls bewusst, wenn, dann passiert sie nebenbei. Mir ist die Fotografie schon sehr wichtig oder genauer, der Bezug zur Fotografie. Als ich anfing, diese Stoffe zu verwenden, hatte dies schlicht damit zu tun, dass ich als Studentin damals kein Geld hatte und Fotohintergründe einfach viel teurer gewesen wären. Deshalb habe ich kostengünstigere Stoffe verwendet und seltsamerweise sehen diese stumpfen, billigen Stoffe immer am besten auf den Fotos aus. Ich habe zudem auch die Angewohnheit, von Reisen stets irgendwelche Stoffe mitzubringen. Auch wenn ich irgendwo Ausstellungen habe, sammele ich Stoffe, die ich dann hier in meinem Atelier erst einmal liegen lasse.

Isabelle Graw Und was interessiert oder fasziniert dich an den Stoffen? Sind es die Farben? Via Stoff dringt ja Farbigkeit massiv in deine Bildsprache ein.

Annette Kelm Farbe ist es auf jeden Fall.

Isabelle Graw Schlagen dich ihre Muster in den Bann?

Annette Kelm Weniger. Eher ihre Struktur.

Isabelle Graw Nimmst du den Stoff auch deshalb, weil er traditionell mit der weiblichen Sphäre assoziiert ist und etwa die Mode ins Spiel bringt, also einen angewandten Bereich?

Annette Kelm Vielleicht, aber mir geht es weniger um die Assoziation mit Weiblichkeit als um den durch den Stoff bewirkten Eindruck von Körperlichkeit. Meine Vorliebe für Muster stammt sicherlich auch aus meiner Kindheit in den 1970er Jahren, wo alles gemustert war. Angefangen von den Tapeten …

Isabelle Graw … bis hin zum Bettzeug.

Annette Kelm Ich erinnere mich vage, dass da Pferde drauf waren – ich hatte braune Pferde und mein Bruder hatte braune Fußballschuhe. Ich finde es übrigens merkwürdig, dass Fotografie immer noch abgegrenzt wird, dass etwa reine Fotografieausstellungen organisiert werden. Es gibt auch diese komische Fotokunstszene, die sich ihr eigenes Süppchen kocht. Das hat mich eigentlich noch nie besonders interessiert.

Isabelle Graw Womöglich hängt diese Singularisierung der Fotografie damit zusammen, dass es sich um ein relativ junges Medium handelt?

Annette Kelm Schon möglich – aber die Videokunst ist doch noch jünger und wird fast nie separat ausgestellt. Dies gilt ebenfalls für die Installationskunst, die auch nicht isoliert gezeigt und von anderen Medien abgegrenzt wird.

Isabelle Graw Aber neigt man nicht in der Kunstwelt inzwischen ohnehin dazu, von einem pluralen Medienbegriff auszugehen und unterschiedliche Medienformate in einer Ausstellung nebeneinander zu zeigen oder als Teile ein und derselben künstlerischen Praxis anzusehen?

Annette Kelm Ja. Dennoch gibt es Künstler wie zum Beispiel Martin Parr, die in rein fotografischen Kontexten gezeigt werden. Auch Künstler wie William Eggleston oder Stephen Shore werden selten mit anderen Künstlern zusammen gezeigt. Ich war deshalb immer froh darüber, dass meine Arbeiten eher in jenen Zusammenhängen zirkulieren, in denen es gar nicht so sehr darauf ankommt, ob man fotografiert oder in anderen Medien arbeitet.

Isabelle Graw Dennoch denke ich, dass sich die Fotografie seit ihrer Entstehung an der Malerei orientiert hat. Die Soziologin Raymonde Moulin hat diesbezüglich eine interessante These aufgestellt. Schon die frühe Fotografie im 19. Jahrhundert hätte sich die Malerei zum Vorbild genommen, um als Kunst Anerkennung zu finden. Indem sie etwa ihre Auflagen begrenzte, ahmte sie das Unikatsideal der Malerei nach.

Annette Kelm Diesen Gedanken könnte man noch weiterführen. Denn Künstler wie Andreas Gursky haben die Fotografie durch ihre Orientierung an der Größe des Tafelbildes ja ins Museum gebracht. Das ist noch gar nicht so lange her.

Isabelle Graw Allerdings könnte man die Fotografie auch als ein Medium charakterisieren, das Wirklichkeit denotiert, wie es

Roland Barthes treffend formuliert hat. Es hat mit der Indexikalität ihrer Zeichen zu tun, dass die Fotografie als eine Spur von Lebenswelt erfahren werden kann – sie suggeriert eine physische Verbindung zur Realität, die anwesend zu sein scheint, obwohl sie abwesend bleibt. Interessanterweise spielt das Thema Spur in deiner Arbeit eine zentrale Rolle – ich denke hier etwa an jenes Bild von Pferdehufen im Schnee (*Untitled*, 2001). Die Hufe sind sichtbar, haben aber auch Abdrücke hinterlassen. Auch der Pferdekörper wirft einen Schatten, der als Spur erfahrbar wird.

Annette Kelm Eine solche Frage ist für mich schwer zu beantworten. Ich lege mich ungerne inhaltlich fest, was meine Arbeit betrifft. Denn so läuft man Gefahr, dass es immer dieser von mir genannte Aspekt sein wird, der in den Vordergrund gestellt wird. Und ich ziehe es eigentlich vor, wenn der Bedeutungshorizont meiner Arbeit eher offen bleibt. Ich finde es grundsätzlich schwierig, wenn man als Künstlerin seine eigene Arbeit interpretiert oder erklärt.

Isabelle Graw Ich wollte eigentlich nur wissen, ob dich das Thema Spur womöglich deshalb interessiert, weil auch die Fotografie als Spur von etwas aufgefasst werden kann. Das Thema Spur klingt auch in einer neueren Serie von Bildern, die von einem Magneten bewegte Eisenspäne zeigen, an (*Untitled*, 2012). Man sieht die Spur des hufeisenförmigen Magneten wie auch die Spuren des von ihm erzeugten Magnetismus – also die Form der Eisenspäne, die durch ihn in bestimmte Konstellationen gebracht wurden.

Annette Kelm Ich hatte zuerst die Magnete fotografiert und daraus Stillleben gemacht. Die Magnete hatte ich im Internet bei einem Schulbedarfshandel bestellt – das waren ganze Schulsätze inklusive Eisenspäne. Ich fühlte mich stark an frühere Physikexperimente erinnert und fing an, zu experimentieren. Einerseits habe ich die Eisenspäne wie zufällig hingestreut und andererseits habe ich minimale, gleichsam malerische Eingriffe vorgenommen, um bestimmte Konfigurationen zu erzeugen.

Isabelle Graw Das Ergebnis sieht aus wie der Abdruck eines Katzenfells.

Annette Kelm Ja, das hat etwas Fellhaftes.

Isabelle Graw Aber auch in der Serie der Palme (*I Love the Little Baby Giant Panda, I'd Welcome One to My Veranda*, 2003) scheint es um das Thema Spur zu gehen – die Palmenwedel drehen sich nach dem Wind, sie zeigen den Wind an, werden von ihm bewegt, sind physisch mit ihm verbunden und machen ihn als Abwesendes anwesend.

Annette Kelm Diese Bilder habe ich tatsächlich nachts im Sturm auf Mallorca aufgenommen. Es hatte etwas von einer Studioaufnahme, weil ich wusste, wenn ich diese Palmen anblitze, wird der Hintergrund schwarz sein. Ich wollte die Sequenz einer Palme haben, die verschiedene Zustände – bedingt durch den Wind – durchläuft. Es trifft sicherlich zu, dass bei der Fotografie immer sogleich ein Wirklichkeitsbezug unterstellt wird. Die Leute wollen ganz genau wissen: Was war das jetzt? Bei Malerei fragt nie jemand so genau nach. Hinzu kommt, dass es natürlich auch Probleme mit den Bildrechten gibt, wenn ich etwas abfotografiere.

Wenn ich es abmalen würde, würde sich wahrscheinlich niemand für die Frage der Bildrechte interessieren. Aber in dem Moment, wo ich etwas abfotografiere, wird der Vergleich mit der Wirklichkeit gezogen. Obwohl es eigentlich nur unsere Wirklichkeit ist, aus der Perspektive eines Menschen betrachtet. Als Hund würde ich sie ganz anders wahrnehmen.

Isabelle Graw (lacht) Du scheinst mir aber auch Vorkehrungen dagegen zu treffen, dass sich alle sofort auf die Frage nach der dargestellten Wirklichkeit stürzen. Einen Großteil deiner Bilder hast du zum Beispiel mit „Ohne Titel" betitelt, was Assoziationen eindämmt. Bei dem Bild des *Seiler Meteorit Piano 116* fiel mir zudem diese Distanziertheit, das Lakonische der Darstellung auf. Man versteht sogleich, dass es nicht nur um dieses Objekt geht, dass man sich nicht ausschließlich für dessen Geschichte interessieren soll. Anders als zahlreiche Künstler/innen, die auf die Aufgeladenheit ihrer Gegenstände setzen, geht es bei dir nicht in erster Linie um die vermeintliche Interessantheit des fotografierten Objekts.

Annette Kelm Auf jeden Fall. Ich versuche, Gegenstände, Stoffe oder auch Personen zu finden, die eine Art Bedeutungsoffenheit zulassen, welche ich dann für meine Zwecke nutzen kann. Ich suche nach Dingen, die so weitgehend wie möglich entleert sind. Zwar ist Symbolik oft nicht zu vermeiden – und Symbole sind ja überall vorhanden –, aber ich versuche, die Symbolik in den Hintergrund zu drängen, sodass man den fotografierten Gegenstand nicht nur als Symbol wahrnimmt, sondern als genau den Gegenstand, von dem zugleich auch abstrahiert werden kann. Auch für „Ohne Titel" entscheide ich mich zumeist aus dem Grund, das ich nicht zuviel festlegen und das Bild möglichst offen halten möchte. Früher habe ich ja oft Titel wie *After Lunch Trying to Build Railway Ties* gewählt. Das ist der Titel von einem Eukalyptuszweig, den ich vor einem Stoff fotografiert habe. Er bezieht sich darauf, dass man in Los Angeles, wo ich das Bild aufgenommen habe, früher Eukalyptusbäume gepflanzt hat, um daraus Bahnschwellen zu bauen. Das hat aber nicht funktioniert, weil das Holz viel zu weich war. Auch ich kam mir wie jemand vor, der etwas zu machen versucht, was nicht funktioniert. Es handelt sich hier also eher um einen poetischen Titel, der eine Stimmung wiedergibt.

Isabelle Graw Einerseits forciert Fotografie das Losstürzen auf den Gegenstand. Andererseits wird in deiner Arbeit in dieser Hinsicht entgegengesteuert, etwa durch die sachlich und distanziert wirkende Ästhetik. Das ist deine Handschrift, wenn man so will, die am Ende wichtiger zu sein scheint als das jeweils Dargestellte.

Annette Kelm Ich weiß jetzt nicht so recht, was ich dazu sagen soll.

Isabelle Graw Ich denke zum Beispiel an die Serie der zum Teil farbigen Baseballkappen (*Caps,* 2008).

Annette Kelm Bei denen ist aber wenig von meiner Handschrift zu erkennen: Ich habe sie sehr neutral fotografiert, so als würden sie für einen Werbekatalog aufgenommen, von der Seite und schräg von vorne …

Isabelle Graw Stimmt – das verleiht ihnen Nüchternheit und Sachlichkeit. Nur kommt einigen Kappen durch ihre Farbbänder eine beinahe expressive Vitalität zu, die die kühle Studioästhetik ein wenig durchbricht.

Annette Kelm Vielleicht stecke ich zu tief in meiner Arbeit drin. Ich versuche, manche Dinge möglichst neutral zu fotografieren und mich eigentlich weitgehend herauszuhalten. Am allerneutralsten sind ja die von mir fotografierten Stoffe von Dorothy Draper – das sind eigentlich nur Repros. Die hätte auch jeder andere so aufnehmen können.

Isabelle Graw Ist nicht gerade diese Neutralität deine Handschrift? Außerdem bist du es, die bestimmte Stoffe, wie auch einen bestimmten Ausschnitt und eine bestimmte Einstellung ausgesucht hat.

Annette Kelm Das sind aber nur minimale Entscheidungen. Natürlich muss man immer den Ausschnitt festlegen oder die Kamera, mit der man fotografiert, oder die Größe des Prints, in der das Bild ausgestellt werden wird.

Isabelle Graw Hinzu kommt, dass die Ornamentik der Stoffe der von dir angestrebten Neutralität entgegenwirkt. Ich halte deine großen Prints, etwa *Big Print #5* (2007), für die malerischsten, gleichsam wildesten Arbeiten. Auch wenn sie zugleich einen Moment der Distanzierung aufweisen und irgendwie kalt wirken, was an dem kühlen Licht wirken mag.

Annette Kelm Ich vermeide es oft einfach, Schatten zu haben. Schatten erzeugen eine merkwürdige Stimmung – jedes Spiel mit Licht und Schatten hat so etwas Fotografisch-Heimeliges, das ich nicht so gerne mag. Und deshalb finden auch viele Fotografen meine Arbeit nicht gut, weil sie denen zu wenig fotografisch ist. Es geht ja in der Fotografie prinzipiell um Licht und Schatten – und das kommt bei mir wenig vor.

Isabelle Graw Was genau ist dein Problem mit Schatten?

Annette Kelm Dass es immer gleich so stimmungsvoll aussieht. Es kommt zu einer Art Überhöhung. Wenn ich jetzt etwa ein Ei fotografieren würde mit einem langen Schatten, wie in einer Bauhaus-Fotografie, wo sich der Schatten dann am besten noch in einem Glas weiterbricht, dann ist mir der Effekt zu theatralisch. Es ist schon schwer genug, Gegenstände zu fotografieren und ihre Symbolik herauszuhalten. Wenn ich mir jetzt noch den Schatten vorstelle, den das Objekt wirft, dann wird es zu etwas ganz anderem.

Isabelle Graw Es wird dir zu expressiv?

Annette Kelm Genau.

Isabelle Graw Es gibt aber auch Bildserien, etwa die Bilder dieser langsam umfallenden Lampe *Untitled* (2010), in denen du dem fotografierten Objekt eine Art Ausdruck zugestehst – es wirkt eigentätig. Die Lampe fällt ja wie von selbst um, so als hätte sie ihre eigene Dynamik.

Annette Kelm Aber nur minimal. Man könnte diese Bilder viel dramatischer inszenieren. Ein wirkliches Fallen sieht ja ganz anders aus. Ich hatte die Lampe an einer Nylonschnur festgebunden und

habe sie immer wieder ein Stück heruntergelassen. Hier kam eine Art Trick zum Einsatz. Mir fällt es zudem oft schwer, mich für ein Bild zu entscheiden, und deshalb habe ich dann mehrere Aufnahmen und finde es auch gut, eine Serie zu haben. Das Bild des Gegenstandes erweitert sich und wird größer.

Isabelle Graw Es fächert sich auf, es pluralisiert sich.

Annette Kelm Darin besteht auch die Möglichkeit der Fotografie – dass man unendlich viele Bilder machen kann und über diese dann verfügt.

Isabelle Graw Bei der umfallenden Lampe und generell in deinen seriellen Arbeiten passieren zwei Dinge zugleich – die Zeit wird eingefroren und zugleich wird ihr Fortschreiten gezeigt. Ganz buchstäblich gilt dies für das Bild der Taschenuhr, *Anonymous, Lilac Clock Bag Buffalo Exchange* (2007). In demselben Maße, wie die Zeit aus diesem Bild wie herausgefallen zu sein scheint – das Objekt hat weder Zeit noch Raum und wurde jeglichen Kontextes beschnitten –, wird aber auch der Ablauf von Zeit durch das Fortschreiten des Uhrzeigers unmittelbar suggeriert. Diese Bilder wirken filmisch, vergleichbar etwa den Bewegungsbildern von Muybridge …

Annette Kelm Fotografie hat immer auch mit Zeit zu tun. Man muss für jede Aufnahme, die man macht, eine Verschlusszeit wählen – Blende und Zeit, das sind die Konstanten der Fotografie, auch in der Dunkelkammer. Es geht immer um Blende und Zeit.

Isabelle Graw Kannst du das genauer erklären?

Annette Kelm Die Blende ist diese Öffnung bei der analogen Kamera, die man weiter auf- oder weiter zumacht. Wenn man zum Beispiel eine ganz kleine Blende nimmt – 22 –, dann wird das Bild relativ scharf. Bei 5,6 ist es so, dass beispielsweise die Augen des Porträtierten scharf und der Rest des Bildes unscharf werden. Und das ist immer proportional zur Zeit.

Isabelle Graw Zeit entscheidet über das Ergebnis und zugleich wirken deine Bilder so, als sei die Zeit in ihnen stehengeblieben.

Annette Kelm So ist es ja auch. Es ist ein kleiner Moment, den du so nie wiederherstellen kannst.

Isabelle Graw Man könnte eine Abwesenheit von Kontext in deinen Arbeiten konstatieren, weil die einzelnen Gegenstände isoliert gezeigt und aus ihrer Umgebung herausgebrochen werden. Zudem werden sie kühl inszeniert. Anders funktionieren jedoch die Porträts von Freund/innen – hier scheinst du eine Art Standortbestimmung vornehmen zu wollen, so als würdest du dein Soziales vorführen.

Annette Kelm Nein, das auf gar keinen Fall. Der Grund dafür, dass ich Freunde porträtiere, ist eher pragmatischer Natur – mir wäre es schlicht unangenehm, mit einer fremden, mir nicht vertrauten Person hier in meinem Atelier herumzustehen. Die Arbeit mit analogen Kameras ist ziemlich umständlich und zuweilen auch recht langwierig. Deshalb ist es mir lieber, wenn ich die zu fotografierende Person kenne und mag. Bei dem Porträt von Michaela Meise (*Michaela Coffee Break,* 2009) hatte ich, während wir etwas Trinken gegangen waren, festgestellt, dass

sie von einer Minute auf die andere ganz anders aussehen kann, dass sie plötzlich einen ganz anderen Gesichtsausdruck annimmt. Das wollte ich festhalten. Aber ich möchte mich mit diesen Bildern keineswegs innerhalb einer Szene verorten – im Gegenteil: Die Personen sind von mir eher im Hinblick auf visuelle Gesichtspunkte ausgesucht worden. Viele meiner Ideen kommen mir ja im Alltag. Wenn wir uns jetzt zum Beispiel unterhalten, dann sehe ich diese Flasche hier stehen und stelle sie mir in einem bestimmten Licht vor. Ich denke also über diese Dinge nach und habe sie im Kopf. Irgendwann kommt der Moment, wo alles stimmt und ich die Sachen zusammenbringen kann.

Isabelle Graw Bedeutet dies, dass es in deinen Porträts von Freunden überhaupt nicht darum geht, im Sinne der heute vielbeschworenen Netzwerkkunst die eigenen sozialen Netzwerke zu visualisieren?

Annette Kelm Nein, das fände ich auch total unangenehm, aus diesem Ansatz habe ich mich immer rausgehalten, von Anfang an. Ich mag ein solches Vorgehen überhaupt nicht. Außerdem kennt man die Personen, die in meinen Bildern auftauchen, in zahlreichen Kontexten, in denen meine Arbeiten ausgestellt werden – etwa in Japan –, überhaupt nicht.

Isabelle Graw Nehmen wir dein Porträt von Julian Göthe – eine Serie, die aus drei Aufnahmen besteht, *Julian, Italian Restaurant* (2008). Sein Auge scheint von Bild zu Bild zu springen. Die Serie gleicht einer Untersuchung seiner Mikrogesten und minimalen Bewegungen. Er wird jedoch nicht als Stellvertreter eines Typus untersucht und im Unterschied etwa zu dem Ansatz von August Sander erfährt man auch nichts über seinen Hintergrund, seine Arbeit, seine soziale Positionierung.

Annette Kelm Zunächst einmal mag ich Julian wahnsinnig gern – er ist ein guter Freund. Mir gefällt seine markante Brille und er trägt sehr oft Poloshirts, das finde ich auch gut. Ich wusste zudem, dass er Lust darauf hat, solche Inszenierungen mit mir auszuprobieren. Wir haben die Szene vor dieser Backsteinwand in meinem Atelier improvisiert, auf dem Tisch liegt ein Tischtuch von Dorothy Draper. Ich hatte es auf eBay ersteigert und wollte damit so eine Art Restaurantszene nachspielen. Das Bild macht auch Anleihen bei einem Bild von Horst P. Horst mit Greta Garbo. Wir haben also diese Szene nachgestellt. Ich wollte nicht nur ein Bild haben, sondern eine Serie.

Isabelle Graw Sind die einzelnen Bilder also in ganz engem zeitlichen Abstand zueinander aufgenommen worden?

Annette Kelm Bei Porträts muss man ohnehin immer richtig viele Bilder machen, weil die Person oft die Augen schließt et cetera. Für Gegenstände muss ich manchmal nur zwei, drei Aufnahmen machen, dann sind sie im Kasten, für Porträts brauche ich bis zu zwei, drei Filme. Es sind allerdings keine wirklichen Porträts im Sinne von „die Person porträtieren". Ich nutze die Personen eigentlich eher wie Gegenstände.

Isabelle Graw Die Personen wirken objekthaft, das stimmt. Geht es dir darum, die Tatsache abzubilden, dass wir uns in einer

Celebrity-Kultur objekthaft inszenieren müssen, dass wir selbst zum Objekt werden?

Annette Kelm Darum geht es mir gar nicht.

Isabelle Graw Aber warum fotografierst du Personen wie Objekte?

Annette Kelm Mich interessiert es eben nicht, die Seele des Porträtierten nach außen zu bringen. Das können andere Fotografen besser. Mich interessiert der Bezug meiner Fotografien zur Fotografie im Allgemeinen und zur Porträtfotografie im Besonderen. Ich ziele darauf, von der Person zu abstrahieren, so etwas wie die Person an sich zu zeigen.

Isabelle Graw Geht es dir also darum, das Allgemeine im Individuum stärker zu betonen?

Annette Kelm Ja – ich möchte etwas Allgemeingültiges zeigen.

Isabelle Graw Könnte man deine Porträtfotos vor diesem Hintergrund mit den frühen Porträtfotos von Thomas Ruff in Verbindung bringen? Auch ihm ging es nicht um Charakter oder Seele, sondern um die Prägung des Einzelnen durch ein bestimmtes soziales Universum, durch eine bestimmte kulturelle Atmosphäre.

Annette Kelm Ja, nur arbeitet Ruff mit einer sehr viel strengeren Versuchsanordnung. Alle Porträts sind gleich. Meine Bilder sind hingegen insgesamt ein bisschen verspielter. Ich mag von der Einstellung her den gleichen Ausgangspunkt haben, nur wird es mir dann ein bisschen zu langweilig, wenn ich mir vorstelle, dass ich ein und dasselbe Prinzip bei zwanzig Leuten durchziehe. Ich integriere immer noch andere Elemente und bringe dann diese unterschiedlichen Aspekte zusammen, versuche, sie zu mischen.

Isabelle Graw Es gibt eine Arbeit von dir, *Turning into a Parrot* (2003), die einen Papagei zeigt und das ödipale Verhältnis des Künstlers zu seinen künstlerischen Vorbildern aufwirft. Der Papagei war ja schon bei den Impressionisten Sinnbild für das Nachmachen in der Kunst: Man arbeitet sich an Vorbildern ab, plappert aber auch nach.

Annette Kelm Man macht ja nie etwas aus dem Nichts heraus.

Isabelle Graw Trotzdem greifst du oft hoffnungslos überdeterminierte Motive wie das Bouquet-Thema in *Untitled* (2012) auf, das Künstler von Bas Jan Ader über Christopher Williams bis hin zu de Rijke/de Rooij variiert haben.

Annette Kelm Ich finde es gerade gut, überdeterminierte Motive aufzugreifen, die dadurch auch wieder bedeutungslos oder total banal werden. Blumen sind ja etwas ziemlich Banales. Gerade dort, wo so viel gemacht wurde, kann man doch wieder etwas Eigenes herstellen.

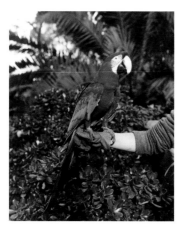

Turning into a Parrot, 2003

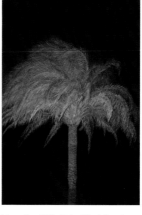

I Love the Little Baby Giant Panda,
I'd Welcome One to My Veranda, 2003

Big Print #2 (Maui Fern – Cotton "Mainsail
Cloth" Fall 1949 Design Dorothy Draper,
Courtesy Schumacher & Co), 2007

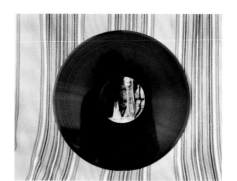

Target Record, 2005

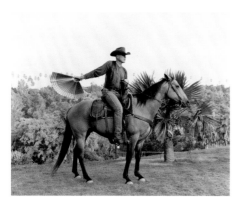

Untitled, 2005

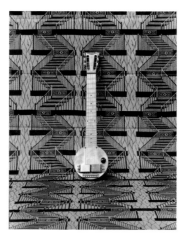

Frying Pan, 2007

Between Tableau and Counterpresence:
The Photography of Annette Kelm

Tom McDonough

But the important question is:
what kind of picture emerges from this?[1]

Any approach to the remarkable body of photographic work produced over the last decade by Berlin-based artist Annette Kelm must begin by acknowledging the radical interpretive uncertainty with which her deadpan images confront their viewers. That uncertainty is inscribed in the incompatible accounts that even her most authoritative commentators provide. Here is Michaela Meise, Kelm's contemporary, colleague, and sometime subject: "Nothing is actually hidden in Annette's photographs. While it is sometimes good to know who built this house at which point in time, who designed that furniture, or to whom or what the title refers, in most cases the photos deliver their own contexts and are in a certain respect complete. The photo is a fact and it shows facts."[2] And here, just a few years later, is Beatrix Ruf, then Director of the Kunsthalle Zürich and co-curator of a major exhibition of the artist's work: "She contaminates the factual. Perhaps one can say she lays 'false trails' [. . .]."[3] So we are already faced with two contradictory characterizations of the work: as factual, objective, and empirical (it's no coincidence Meise begins her account with an epigraph from Ludwig Wittgenstein) or, alternatively, as deceptive, misleading, and constructed as fiction.

We need not—indeed, we must not—adjudicate between these options; nor should we look toward the interpretive horizon of some imagined synthesis of the two. Rather, the task will be to hold onto both readings at once, to understand Kelm's photographs as occupying the paradoxical, even antagonistic position of simultaneously showing facts and laying false trails. The sort of reading called for is allegorized within her work itself: *Untitled* of 2004, one of a rather large number of photographs made during a yearlong stay in Los Angeles, is an image dominated by four thin wooden panels with elaborately shaped edges that are propped up to form the kind of palisade one might find demarcating an outdoor patio. But it is also an image that asks us to negotiate a variation on a famous optical illusion—the so-called "Rubin's Vase" illusion, in which figure-ground relations become reversible: with protracted observation, the negative space between the panels suddenly evokes a positive form, something like an intricately turned post, much like the alternation between silhouette profiles and vase in the classic example. It is an illusion dependent upon our mind's edge-assignment (in that the shape we see at a given moment hinges on the direction of the border or edge of the form), and Kelm's *Untitled* can very well be understood as a work on

edges—not only in regard to those of the palisade, but also to how the panels at either edge are themselves cut off (the one on the left interrupted neatly by the frame of the photograph, the one on the right rather less neatly by the trunk of a palm tree, itself sliced off by the frame). So we might say that this picture uneasily brings together objectivity and a certain deceptiveness. Of course, we will also have to take a further step beyond what the work itself may suggest, and ask what logic might govern this strange conjunction.

One place to begin is by noting the strongly self-reflexive character of Kelm's photographic practice—that is, the existence of an ongoing subset of her images that refer to photography itself, its history and ontology. An early example may be found in *Turning into a Parrot* of 2003, which shows a gloved arm reaching into the picture plane from the right, upon which rests a large parrot before a lush backdrop, including a sizeable jade plant that occupies much of the fore- and middle grounds. To *parrot,* of course, is to repeat something mindlessly and mechanically, to duplicate or mimic without understanding—much like the photographic apparatus itself. As French legal theorist Bernard Edelman has demonstrated, the technique of photography was, in the nineteenth century, initially represented as lacking in personality, as a purely mechanical procedure with the industrial capacity to produce multiple and perfect copies (as opposed to the notion of the Romantic author or creator as an exemplary individual). The machine marked the excluding limit—the border or edge—of the subject.[4] Only later was the "soulless craft" of photography invested with the personality of its maker, but *Turning into a Parrot* reminds us of the ever-present possibility of the medium's lapse back into rote repetition. If the brown leather glove worn by the keeper of this tropical bird has reminded some viewers of the appurtenances of falconry, this only reinforces the allegory of photographic postmodernism: from falcon (a bird of prey renowned for its keen, quick eyes that recalls the photographer's ability to capture the "decisive moment") to parrot (the copier).[5]

We might similarly group Kelm's various treatments of the theme of the target as further restatements of the photographic apparatus, another form of the "monocular double of the camera lens" that Walead Beshty has identified in her work.[6] For example, the three pictures of *Friendly Tournament* (2005) record the hanging paper targets of an archery competition, positioned dead

center within the square frame of the image against a black foam ground, scored with hundreds of punctures from arrows that missed their mark. This would appear a relatively straightforward analogy to the viewfinder of the camera, to the pointing of the lens toward its target, until we learn that these bull's eyes record the results of a Zen archery tournament, in which—to quote Daisetz T. Suzuki's introduction to *Zen in the Art of Archery* (the book that introduced the concept of Zen to the West)—"the archer ceases to be conscious of himself as the one who is engaged in hitting the bull's eye which confronts him."[7] Vision is dethroned and consciousness is displaced in favor of a surrendering of self; a curious blindness is engendered. But perhaps the most complex articulation of the target theme is found in another photograph of 2005, *Target Record.* A black vinyl LP dominates the center of the image before a fabric backdrop; its label is comprised of a photograph of a cavern, with stalactites and stalagmites—a "target," as it were, constituted by the concentric circles of record, label, and central spindle hole. The analogies with the photographic apparatus are multiple: there is the target-as-viewfinder motif once again but also the cave, which becomes something like the mysterious interior of the camera itself—an impression only heightened when we recognize that it is upside-down, so that stalactites rise up from the floor, much as an image is flipped by the lens. In fact, the label photograph is a reprise of an earlier two-part work by Kelm: *Cave* (2003), in which this grotto is seen upside-down and then correctly orientated. *Target Record,* by drawing out the analogy to the camera and its hidden interior, could be said to reveal the logic of these pictures, which thus become a demonstration of the *camera obscura.* Kelm has spoken of her interest in the formations within the cave as registrations of time—the hanging icicles and rising columns of calcite record deposits of mineral-rich water over centuries and millennia—and Caoimhín Mac Giolla Léith has perceptively noted the parallel with the record's logging of sound: "We might take the physical registration of duration symbolized by these dripstones to be broadly analogous to the phonographic registration of sound, thereby binding the image of the record to the image on the record thematically."[8] We could go further, however, and note that what is at issue in each case is a mode of indexical recording: in the geologic time of the stalactite / stalagmite formations, in the durational time of the LP, and in the instant of the photograph itself. Binding them together is the reflection of Kelm herself taking the picture, seen hazily on the black vinyl of the record.

Mention of the index, the *camera obscura* and the like makes this an appropriate moment to recall that Kelm continues to work with analogue equipment, using a 4 × 5 inch field or middle-format camera and developing her own C-prints in the darkroom—all decisions that place her in many ways at odds with the defining practices of recent art photography, dominated as they have been by digital technologies. Her relation to those practices is humorously signaled in an untitled photograph of 2009, in which a small

three-masted schooner, flags proudly flapping in the breeze, sails past a massive container ship whose length stretches out past either side of the picture's frame: standardization, corporate anonymity and contemporaneity on one hand; craft, idiosyncrasy and anachronism on the other. The two ships, not coincidentally, are heading in opposite directions. *Untitled* measures about 2 × 3 feet, making it actually a rather large work in Kelm's oeuvre, although this is of course quite modest by the standards of contemporary photography, particularly those of the so-called "Becher school"— Andreas Gursky, Candida Höfer, Thomas Ruff, Thomas Struth, et al. These photographers produce what Jean-François Chevrier has called the "tableau form," pictures that are "designed and produced for the wall, summoning a confrontational experience on the part of the spectator that sharply contrasts with the habitual processes whereby photographic images are normally received and 'consumed.'"[9] In their scale and size, such photographs are meant to "hold the wall" and to impose a distance between viewer and object akin to that of painting—when faced with these large-scale works, the observer has to stand back in order to take it all in. Michael Fried has called this "the most decisive development in the rise of the new art photography," emphasizing the "confrontational experience" and the break with conventional models of the reception of photography via the small-scale print: i.e., if, prior to the later 1970s, photographs had been made to be looked at closely—in a book or magazine, on the page—the large "tableau form" was conceived to be hung on the wall.[10] The moment that happens, the photograph engages in a relationship with the viewer standing before it and, for Fried, photography thereby inherits all the problems of painting that date back to the eighteenth century and Dénis Diderot, the entire history of the struggle between modernist absorption and anti-modern theatricality.

Kelm has clearly signaled her conflicted filiation with the work of Bernd and Hilla Becher and their students, most particularly in two bodies of work produced in 2008—that is, at the very moment Fried was articulating his own late modernist exegesis of the tableau form. One series consists of photographs of wooden houses built in Germany from the 1890s to the early 1930s in various neo-traditional, regional styles, often as quasi-industrialized prefabricated architectural experiments. For example, three photographs depict houses produced by the Wolgaster Holzindustrie Aktiengesellschaft, whose prefabricated wood houses for resort towns along the Baltic are classic examples of later nineteenth-century spa architecture, as well as being some of the earliest examples of prefabrication in Germany. Jens Hoffmann has written that this body of work investigates the history of that architectural form, noting how, "by bringing together the notion of ready-made sculpture with the utopian ideals of modernist architecture, perhaps Kelm is suggesting the changed, if not compromised, contemporary position of both."[11] Though possible, this kind of reading-in remains less convincing than

an interpretation of the series as a pointed rejoinder to the architectural photography of the Becher school—especially Thomas Ruff's *L.M.V.D.R.* series (2000–2001), with its celebration of the iconic modernist architecture of Ludwig Mies van der Rohe. Kelm plays a sly game here, photographing rather traditional, frequently rustic houses that were nevertheless highly innovative in their constructive technology, while the houses pictured by Ruff, despite their clean lines and cubic forms, were most often the product of highly artisanal labor; likewise, her relatively small-scale (the Wolgaster prints all measure about 30 × 23 inches), analogue photos are set against Ruff's much larger, digitally manipulated works. But the work that most clearly references the Bechers' typological concerns is Kelm's 20-part *Caps* (2008), which closely echoes their industrial archaeologies, now focusing, however, on the demotic form of a curious baseball cap woven from bast fiber, found by the artist in New York's Chinatown.

Yet, Kelm's reference to this tendency in contemporary photography—to work that formed a crucial horizon of photographic practice during her studies at the Hochschule für bildende Künste in Hamburg in the 1990s, where she began as a painter—does not limit itself to such ambiguous citations. Several works appear to counter the "absorptive" qualities of the tableau form with distinct evocations of theatricality. *Untitled* (2007) depicts the Mighty Wurlitzer that was acquired from its American manufacturer by Ferdinand Werner von Siemens in 1929 and is now on prominent display at the Musikinstrumenten-Museum in Berlin. Although it is the largest organ of its kind in Europe, Kelm refrains from showing off its sets of pipes (located in a gallery above the hall pictured here), instead focusing on the horseshoe-shaped, illuminated console in white lacquer. It is a type known precisely as a "theatre organ," providing musical accompaniment to silent movies and, later, concert performances; it is, we might say, an instrument that most emphatically declares its own "theatricality." The artist surreptitiously placed a reproduction of a Joan Miró work on a column to the right—and, while we certainly notice the formal rhyming of the organ console's U-shaped curves with the abstract artwork, we should also consider the implicit contrast of an exemplar of absorptive modernism and the theatrical near-kitsch quality of the organ. That tension is internalized in the related *Seiler Meteorit Piano 116* (2007), a photograph of an extravagantly futuristic instrument manufactured in the late 1990s by the august German piano firm of Seiler in anticipation of the approaching millennium; here, we seem meant to contrast the absorptive qualities of listening to music with the excessively, almost absurdly, extroverted qualities of the piano itself.

But to this group, we must add one of the most remarkable photographs in Kelm's oeuvre: *Frying Pan* (2007). Once again we are dealing with a rather special musical instrument, in this case the first electric guitar, invented by American musician George Beauchamp in the early 1930s. Here, however, it is not seen in a museum or recording production setting, but as a kind of studio

still life, standing propped against a wall that has been covered in an Escher-like fabric of zigzagging staircases the artist had found at a Paris market. Earlier observers are undoubtedly correct in seeing this "African-patterned piece of fabric" as working to change the guitar "into a seemingly foreign, African-looking musical device."[12] But we might also consider the complex spatial play this photograph sets in motion. This guitar was called a "frying pan" for the appearance of its circular body and long neck, but also for the manner in which it was played: this was a lap guitar, played while sitting down. Despite its vertical orientation in Kelm's photograph, then, its history encodes a horizontality that allegorizes her own refusal of the tableau form: in contrast to the modernist drive to "hold the wall," Kelm encourages another form of looking that remains closer to older modes of photographic consumption, i.e. something more like reading a page. Her insistence on titling the work *Frying Pan* provides the viewer with the cue that may be needed to recognize this play with orientation. The fabric too participates in this spatial ambiguity. Kelm first introduced its use—and this tabletop still life format generally—in *Target Record* and *After Lunch Trying to Build Railway Ties* (both 2005). We see its second appearance here, but she would not fully exploit its potential until 2009 and 2010, first with *Venice Zurich Brussels* (2009) and then *Untitled* (2010), with its fragile propped playing cards sitting on a dizzying fabric of repeated poker hands. In each case, the fabric serves to mask—effectively to eliminate—the horizon line, radically flattening the composition and fundamentally confusing depth cues. Scale becomes difficult to recognize, and the orthogonal space we are used to finding in the photograph gives way to an analogue, improvised version of the flatness of the screen and its attendant technologies of digital manipulation, ones that Kelm has declined to adopt. So while critics have, with the artist's evident encouragement, seen her interest in these musical instruments as deriving from "their liminal status, poised [. . .] on the cusp of technological change in a manner comparable to that of the contemporary photographer," we might note a more complex *play* with the codes of digitalization and the tableau form rather than an outright refusal.[13]

Nowhere is this more clearly articulated than in her *Big Print* series (2007), whose title recalls not only the ostensible subject of the photographs—the fabric line that interior designer Dorothy Draper produced for Schumacher in the 1940s—but also takes a sly jab at the scale issues in contemporary photography highlighted by Chevrier and Fried (and these, we should note, are Kelm's largest pictures, measuring around 51 × 39 inches). Unlike her use of fabric in the works mentioned above, in which it is employed as a backdrop to what are, in effect, tabletop still lifes, the patterned cloth in this series is photographed frontally and absolutely parallel to the plane of the lens. Furthermore, the photographic print reproduces the fabric in its original size. André Rottmann has noted the way "their constantly repeating patterns recall the Greenbergian ideal of a medium-specific painting concentrating

only on questions of opticality and flatness," but, like many other critics of Kelm's work, he then wants to read into them an external commentary on the conflation of high and low, of "the all-encompassing aestheticization of daily life" and "artistic modernism," a dynamic, however, that any objective examination of contemporary visual culture would have to declare moribund.[14] Kelm is not so much interested in demonstrating the long-acknowledged collapse of high art into mass culture—the ideology of modernism is in no simple way her target here—as in referencing the entirely contemporary tendency in photography toward the alignment of the large-scale print with a redemptive late-modernist concept of absorption. She thus gives us the big print, but one that defiantly meets our gaze with the vibrant patterns of Draper's "Modern Baroque" style. We might be reminded of some of Gursky's most abstract photographs (say, his *Untitled XV* [2005], an overhead shot depicting workers rolling out turf on a soccer pitch), but, despite the work's strong, repeated patterns, the viewer's attention is continually called toward the visual anomalies, the small incidents that break the decorative arrangement. The Gursky draws us in, in other words, while Kelm's *Big Prints* insist on their ornamental surfaces, and nothing more.

Her approach toward the post-Becher tableau form, then, is not one of absolute rejection but a kind of subversive performance of its codes. Perhaps we could say that she draws upon a minor or secondary element of that aesthetic, something which Norman Bryson has called a "counterpresence" or "*negative* attention" that, in many ways, is the refutation of Friedian absorption. For Bryson, the Bechers and their students broke with classical photography's paradigm of presence, whereby "the photographic surface acted as a reservoir of information that the eye drew on in a relatively continuous and even process of absorption, from the most striking forms down to the smaller and smallest details." Photography, in other words, had always been "advertent, turned toward the spectator," its reservoirs of meaning ready to be drunk down and exhausted by the viewer's gaze.[15] But with the conceptual turn as instigated by the Bechers, this gaze was blocked: "counterpresence is all about the inadvertent, about deflection and withdrawal," interrupting the smooth process of absorption with a hiatus that "cut the flow, stopped the gaze in its tracks"—in the Bechers' case, through seriality and taxonomic operations that forced meaning to emerge in the comparison between images. The eye was no longer conceived of as a passive receiver of flows of visual information, but was compelled to construct signification from juxtaposition and fragmentation.[16] This counterpresence is explicitly activated in several series within Kelm's oeuvre that we have already examined—the *Wolgaster Holzindustrie Aktiengesellschaft* works (2008) and *Caps* (2008), for example—and is equally evident in subsequent work, such as her four-part *Untitled* piece picturing a field of sunflowers (2009); *Untitled* (2010), with its variously flipped image of a red-and-white checked cloth and a sale tag; or the doubled portrait of *Anna #2* (2011).

But it in fact constitutes the dynamic that is at work across her photography as a whole, and the paradoxical condition of negative attention may account for the interpretive uncertainty with which we began: though nothing is hidden, meaning does not reside in what is visible before us.

Fellow photographer Lisa Oppenheim has another name for it: uncanny.[17] By that term, she means to suggest the ways in which Kelm's photographs are unsettling precisely in their familiarity. Yet, we find relatively few works that take up the eeriness associated with this psychoanalytic trope, and when they do—as in *House on Haunted Hill I (night)* and *II (day)* (both 2005), two photographs of Frank Lloyd Wright's Ennis House—, it is via reference to Vincent Price's campy thriller *House on Haunted Hill* (1959, dir. William Castle), which had used the location for its exterior shots. But the self-conscious weirdness one might associate with, say, the surrealists' interest in the uncanny is not really what Oppenheim has in mind, and the semi-ruined hilltop mansion is something of an anomaly in the artist's work; she is, rather, concerned with the way repetition denaturalizes objects, as in the repeated clock face of *Anonymous, Lilac Clock Bag Buffalo Exchange* (2007)—the title referring both to what is pictured in the four photographs as well as where it was purchased, a Buffalo Exchange used clothing store, "anonymous" presumably indicating a buyer who would rather remain unknown. Here reiteration and decontextualization transform this banal object, lending it a kind of sculptural drama quite different from that of the found object; after all, Buffalo Exchange is no Parisian flea market, the surrealists' favorite haunt in their search for the uncanny and the marvelous. And if Kelm's clock bag, a classic piece of '80s design by Toronto-based designer Marilyn Brooks, is a bit out-of-date, we cannot say it is outmoded or obsolescent, as was the found object, since these bags are precisely coveted by an ironic fringe of hipster youth. If anything, her photos could be said to resemble professional versions of the snapshots of such bags one finds on online style blogs and auction websites. She displays a witty awareness of the protocols of the commodity, subtly altering what is the preferred time in clock or watch advertising—10:10—by ensuring that the minute hand on her clock bag moves forward in each image, ever so slightly skewing the photograph from the ideal.[18]

This, however, still leaves open the question of why Kelm has staked out this critical terrain. Beshty has insightfully called her work a "minor photography," after Gilles Deleuze and Félix Guattari's notion of a "minor literature," noting how it tends toward the anticlimactic: "no series lasts more than a few iterations, and their subjects [. . .] could not be confused for the subject matter of the taxonomer, or the allegorical detritus of a social realist," even if "the tools of their trades persist." Hers is a world of "sliding meanings and innuendo" that "insinuates itself within totalizing structures, turning them to the service of the transitory and contingent."[19] This seems to me by far the most accurate description of Kelm's work that we possess, and is undoubtedly

correct. But we may still ask what gives her access to this minor language. The evidence of the work would indicate that the answer lay at least in part with gender, with the troubling role that feminine identity can still play within dominant cultural categories. Certainly, we can find photographs by Kelm that take up this problematic, perhaps none more plainly than *After Man Ray* (2005), in which a young man, clothed only in a curiously cut-out black garment that leaves much of his torso exposed, raises his right arm over his head in a gesture of exposure and visual availability more commonly associated with depictions of the female nude. He is clean-shaven, but a crude black moustache—whose artificiality is only accentuated by his brown hair—has been appended to his upper lip, apparently by drawing it onto the photographic print. The title points us toward American avant-garde photographer Man Ray, although Kelm's photograph does not seem to echo any particular composition of his; her model's added moustache may well reference the *f*-holes Man Ray painted onto the print of his photograph of Kiki in *Le Violin d'Ingres* (1924)—the technique is identical, and even the form is rather similar. But the title is really rather misleading, since the pose in Kelm's *After Man Ray* is in fact more likely a citation of Maurice Tabard's *Nude* (1929): she has simply transposed the shadows in the Tabard into the forms of the vestigial garment worn by her model—having crucially swapped the young girl for her young man.

The transpositions in *After Man Ray* are uncharacteristically obvious for this artist, making for a rather more explicit statement than is typical in Kelm's work. "I'd find it boring if a photo permitted only one interpretation," she has stated. "Making a picture solely about gender identity would be too dogmatic"—here in reference to her well-known image of a mounted cowboy holding an open fan, which some have read as questioning the masculine clichés of this figure.[20] And, indeed, in discussing the role of gender here, we by no means intend to suggest that Kelm adopts a distinct political agenda or conscious identification with feminism and its legacies in contemporary art. In fact, femininity has more often entered her work through subtle references to women whose cultural contributions have been marginalized, as in the *Big Prints* series and their citation of Draper's fabrics, or her *Untitled* (2007), which depicts the Hameau, or hamlet, designed in rustic style for the use of Marie Antoinette at the Château de Versailles. In neither case does gender enter in any easily recognizable way; rather, we find instances in which feminine identity undercuts the grandiosity of masculine pretensions. We have seen how this operates in the *Big Prints,* and something analogous takes place in *Untitled:* the Hameau, in its small scale and rusticity, was an escape from the overbearing formalization of court life at Versailles, which we can read as another allegorization of Kelm's own relation to dominant photographic practices. But the clearest statement of this theme is found in *Your House is my Castle* (2005), in which the artist had herself photographed, wearing a false beard, in a window of the so-called Casa Storta, or Crooked House, in the sixteenth-century Mannerist garden in Bomarzo, north of Rome. Kelm inserts herself into this strange setting—beloved of the surrealists—and lays claim to it, challenging the dictum that "a man's house is his castle" by occupying this house as her own. That the garden was built for Pier Francesco Orsini in honor of his deceased wife, Giulia Farnese, only amplifies the gesture: from muse to owner, or at least squatter. The move is typical of Kelm's "rather androgynous style," and is the wittiest summation yet of her destabilizing role in contemporary photography, one of working her way into its hegemonic forms only to question them from within.[21]

1 Beatrix Ruf, in "Susanne Pfeffer, Beatrix Ruf and Nicolaus Schafhausen in Conversation," in *Annette Kelm* ed. Susanne Pfeffer, Beatrix Ruf, and Nicolaus Schafhausen (London: Koenig Books, 2009), 64.
2 Michaela Meise, "Sur pointes," in *Annette Kelm: Errors in English* (London: Koenig Books, 2006), 53.
3 Ruf, in "Susanne Pfeffer, Beatrix Ruf and Nicolaus Schafhausen in Conversation," 62.
4 See Bernard Edelman, *Ownership of the Image,* trans. Elizabeth Kingdom (London: Routledge & Kegan Paul, 1979), 37–67.
5 The recollection of falconry is noted in Ruf, "Twisting and Turning," trans. Catherine Schelbert, *Parkett* no. 87 (March 2010): 156.
6 Walead Beshty, "Toward a Minor Photography: Annette Kelm's Discrete Cosmologies," *Parkett* no. 87 (March 2010): 161. The target theme has received a good deal of attention in the critical reception of Kelm's work. See Sabeth Buchmann, "Mistakes are a question of language," in *Annette Kelm: Errors in English,* 15–17; and Caoimhín Mac Giolla Léith, "Target and Record," in *Annette Kelm,* 59–65.
7 Daisetz T. Suzuki, "Introduction," in Eugen Herrigel, *Zen in the Art of Archery,* trans. R.F.C. Hull (New York: Vintage Books, 1989), viii.
8 Mac Giolla Léith, "Target and Record," 63.
9 Jean-François Chevrier, "The Adventures of the Picture Form in the History of Photography," trans. Michael Gilson, in Douglas Fogle, *The Last Picture Show* (Minneapolis: Walker Art Center, 2003), 116.
10 Michael Fried, *Why Photography Matters as Art as Never Before* (New Haven and London: Yale University Press, 2008), 143.
11 See Jens Hoffmann, "Sculptural Moments," in *Passengers: Annette Kelm* (San Francisco: CCA Wattis Institute for Contemporary Arts, 2008), n.p.
12 Hoffmann, "Sculptural Moments," n.p.
13 See Mac Giolla Léith, "Target and Record," 61n12.
14 André Rottmann, "Annette Kelm: Galerie Johann König," trans. Susan Bernofsky, *Artforum* 46, no. 4 (December 2007): 367.
15 Norman Bryson, "From Form to Flux," in *Sharon Lockhart* (Chicago: Museum of Contemporary Art, 2001), 82, 84. Kirsty Bell has previously drawn upon Bryson's notion of "counterpresence" in her reading of Kelm's work; see her "Focus: Annette Kelm," *Frieze* no. 113 (March 2008): 24.
16 Bryson, "From Form to Flux," 84, 82.
17 Lisa Oppenheim, "Annette Kelm: A Precise, Wideranging Scavenger," *Flash Art* no. 271 (March–April 2010): 84.
18 As observed by Susanne Pfeffer, in "Susanne Pfeffer, Beatrix Ruf and Nicolaus Schafhausen in Conversation," 63.
19 Beshty, "Toward a Minor Photography": 162.
20 Annette Kelm, quoted in Tim Ackermann, "Cold, Clear Pictures: Annette Kelm's Conceptual Photo Works," *db artmag* (2008), accessible at http://db-artmag.de/archiv/2008/e/4/2/617.html.
21 The "androgynous" characterization is that of Zoë Gray, "Sense and Sensibility: Pleasure, Pattern and the Picture Plane," in *Annette Kelm,* 68.

Zwischen Tableau und Gegenpräsenz:
Die Fotografien von Annette Kelm

Tom McDonough

Wichtig bleibt immer die Frage:
Welches Bild wird hier zum Vorschein kommen?[1]

Ohne sich mit der grundsätzlichen interpretativen Unklarheit auseinanderzusetzen, welche die trockenen Fotografien der Berlinerin Annette Kelm beim Betrachter hervorrufen, kann man sich ihrem bemerkenswerten, innerhalb der letzten zehn Jahre entstandenen Werkkomplex nicht nähern. Diese Unklarheit zeigt sich darin, dass die Rezeptionen selbst der intimsten Kenner ihres Werkes praktisch nicht auf einen Nenner zu bringen sind. Michaela Meise, Zeitgenössin, Kollegin und gelegentlich auch Modell, schreibt zum Beispiel: „In Annettes Fotos ist eigentlich nichts versteckt. Im einen oder anderen Fall ist es gut zu wissen, wer hat wann dieses Haus gebaut, wer hat diese Möbel entworfen, auf wen oder was bezieht sich der Titel, doch meistens liefern die Fotografien ihre Kontexte mit und sind auf eine Art vollständig. Das Foto ist eine Tatsache und es zeigt Tatsachen."[2] Nur einige Jahre später kommentiert Beatrix Ruf, Direktorin der Kunsthalle Zürich und Mitkuratorin einer großen Ausstellung der Werke der Künstlerin, Folgendes: „Sie kontaminiert das Tatsächliche. Man könnte sagen, sie legt ‚falsche Fährten' […]."[3] Man wird also mit zwei sich widersprechenden Charakterisierungen des Werks konfrontiert: einmal als faktentreu, objektiv, empirisch (es ist kein Zufall, dass Meise ihren Ausführungen ein Motto von Ludwig Wittgenstein vorausschickt) oder, ganz gegensätzlich, als trügerisch, irreführend, als Fiktion konstruiert.

Man muss und soll sich auch gar nicht zwischen diesen beiden Meinungen entscheiden, genauso, wie es sich nicht lohnt, den interpretativen Horizont einer vielleicht vorstellbaren Synthese dieser beiden Standpunkte zu suchen. Die Aufgabe liegt vielmehr darin, beide Interpretationen im Kopf zu behalten und sich Kelms Arbeiten zu nähern, indem man die von ihnen abgedeckten paradoxen, sogar feindlichen Positionen zur Kenntnis nimmt, gleichzeitig Tatsachen abzubilden und falsche Fährten zu legen. Ein Werk der Künstlerin zeigt allegorisch die gebotene Lesart: *Untitled* (2004), eine von zahlreichen während eines einjährigen Aufenthalts in Los Angeles entstandenen Fotografien, ist ein Bild, welches von vier dünnen Holzpaneelen dominiert wird. Diese sind aufwendig geformt und so aufgestützt, dass sie eine Art Palisade darstellen, so wie man sie vielleicht als Abgrenzung eines Außenbereichs kennt. Gleichzeitig lädt uns das Bild ein, uns mit einer Variation der berühmten „Rubin'schen Vase" auseinanderzusetzen, einer optischen Täuschung, bei der die Figur-Hintergrund-Beziehung umgedreht werden kann:

Bei näherer Betrachtung nimmt der negative Raum zwischen den Paneelen positive Form an, einem gedrechselten Pfosten gleich, ähnlich dem Zwischenspiel von seitlichen Profilen und Vase im klassischen Beispiel. Diese Illusion beruht auf dem Bedürfnis unseres Gehirns, der Abgrenzung eine bestimmte Bedeutung zuzuschreiben (die Richtung, in der wir die Kante beziehungsweise Abgrenzung wahrnehmen, bestimmt, was wir jeweils sehen). Kelms *Untitled* kann man problemlos als ein Werk der Abgrenzung bezeichnen – nicht nur der Palisaden, sondern auch der Paneele auf beiden Seiten, die links sehr klar durch den Rahmen beschnitten werden und rechts nicht ganz so klar durch den Stumpf einer Palme, der selbst wiederum vom Rahmen des Bildes in der Mitte durchschnitten wird. Dieses Bild steht also vielleicht für eine unangenehm verstörende Zusammenführung von Objektivität und Irreführung. Man kann sich natürlich immer noch fragen, welcher Logik diese Zusammenkunft geschuldet sein mag, weit über die anscheinende Bedeutung des Bildes hinaus.

Ein guter Ansatzpunkt hierfür ist der auffallend stark selbstreflexive Arbeitsprozess Kelms. Ihre Arbeit durchzieht ein Interesse an Fotografie als solcher, ihrer Geschichte und Ontologie, mit welcher zu beschäftigen es sich lohnt. Ein gutes Beispiel hierfür ist die Arbeit *Turning into a Parrot* (2003), die einen behandschuhten Arm zeigt, der von rechts in die Bildfläche ragt. Auf diesem Arm, der vor einem üppig bewachsenen Hintergrund zu sehen ist, welcher auch einen beachtlichen, den Bildvorder- und Mittelgrund dominierenden Geldbaum beinhaltet, sitzt ein großer Papagei. Im Englischen bedeutet „to parrot" das unreflektierte und mechanische Imitieren, etwas zu duplizieren ohne Sinn und Verstand, dem Wesen der Fotografie also nicht ganz unähnlich. Die Untersuchungen des französischen Rechtstheoretikers Bernard Edelman haben gezeigt, dass im 19. Jahrhundert die Arbeit eines Fotografen zuerst als persönlichkeitsfrei und als rein mechanischer Vorgang gesehen wurde, dessen Möglichkeiten, eine Vielzahl an perfekten Kopien herzustellen, im direkten Widerspruch zum Ideal des romantischen Autors/Urhebers als beispielhaftes Individuum standen. Der Apparat definierte das Ausgeschlossene des fotografierten Gegenstandes, also dessen Grenze.[4] Erst später wurde das „seelenlose Handwerk" der Fotografie mit der Persönlichkeit des Fotografen aufgeladen. *Turning into a Parrot* erinnert uns daran, dass dieses Medium immer in Gefahr steht, in rein mechanische

Wiederholung zurückzufallen. Sollten sich der eine oder andere Betrachter beim Anblick des braunen Lederhandschuhs dieses Tropenvogelbetreuers an die Werkzeuge der Falknerei erinnert fühlen, so wird damit nur die Allegorie auf den postmodernen Fotomodernismus verstärkt: vom Falken, einem Raubvogel schnellen und scharfen Blicks (der Fähigkeit, den „richtigen Augenblick" abzupassen, nicht unähnlich), kommen wir zum Papagei, einem Nachahmer.[5]

Auf ähnliche Weise kann man auch Kelms verschiedenartige Auseinandersetzung mit dem Thema der Zielscheibe als weiteren Kommentar zum fotografischen Apparat verstehen, als weitere Form des „einäugigen Doppels der Kameralinse", welches Walead Beshty in ihren Arbeiten identifiziert hat.[6] So zeigen zum Beispiel die drei Bilder des *Friendly Tournament* (2005) die hängenden Papierzielscheiben eines Bogenschießwettbewerbs, perfekt zentriert im quadratischen Raum. Sie hängen vor einem schwarzen Schaumstoffhintergrund, der von Hunderten ihr Ziel verfehlt habenden Pfeilen durchlöchert ist. Die Analogie zum Sucher einer Kamera scheint hier offensichtlich zu sein – bis man versteht, dass die Einschüsse das Ergebnis eines Zen-Bogenschießturniers sind, in dem – um Daisetz T. Suzukis Vorwort zu *Zen in der Kunst des Bogenschießens* zu zitieren, dem Buch, mit welchem das Konzept des Zen im Westen einführt wurde – der Schütze aufhört, sich „seiner selbst bewusst zu sein, als der, der damit beschäftigt ist, die Scheibe zu treffen, der er sich gegenübersieht".[7] Die Sehkraft wird entthront, das Bewusstsein wird verschoben, alles zugunsten eines sich unterordnenden Selbst, einer seltsamen Blindheit. Die wohl komplexeste Auseinandersetzung mit der Zielscheibenthematik aber zeigt ein anderes Werk: *Target Record* (2005). Im Zentrum des Bildes steht eine schwarze Langspielplatte vor textilem Hintergrund; das Label zeigt das Foto einer Höhle mit Stalagmiten und Stalaktiten – eine Zielscheibe also, dargestellt durch die konzentrischen Kreise von Platte, Label und zentralem Spindelloch. Hier finden sich vielfältige Analogien zum Fotoapparat: das „Zielscheibe als Sucher"-Motiv, aber auch die Höhle, die zum geheimnisvollen Innenleben einer Kamera wird, ein Eindruck, der sich erst recht vertieft, bemerkt man, dass dieses Bild auf den Kopf gestellt ist und die Stalaktiten aus dem Boden ragen, ähnlich einem von der Linse umgedrehten Bild. In der Tat ist das Labelbild eine Reprise einer früheren zweiteiligen Arbeit Kelms, *Cave* (2003), in der eine Grotte einmal auf den Kopf gestellt und einmal richtig herum zu sehen ist. Indem *Target Record* die Analogie zur Kamera und ihrem verborgenen Innenleben ausarbeitet, entdeckt es zugleich auch die Logik dieser Bilder, die selbst zu einer Vorführung der Camera obscura werden. Wir wissen von Kelm, dass sie sich für Tropfsteine als Ausdruck vergehender Zeit interessiert – die hängenden Gebilde und hochragenden Säulen sind Zeugen jahrtausendelanger Ablagerungen mineralhaltigen Wassers. Sehr feinsinnig hat Caoimhín Mac Giolla Léith die Parallele zu der Eigenschaft von Platten, Töne festzuhalten, festgestellt: „Man könnte die physische

Repräsentation von vergangener Zeit, symbolisiert durch diese Tropfsteine, als im weitesten Sinne analog zur phonographischen Aufzeichnung von Ton sehen und so das Bild *von* der Platte und *auf* der Platte thematisch verbinden."[8] Diesen Faden weiterspinnend könnte man sagen, dass hier auf jeden Fall eine indexhafte Form des Festhaltens zur Diskussion steht: die geologische Zeit der Stalagmiten/Stalaktiten-Formationen, die Laufzeit einer Langspielplatte und der fotografische Augenblick selbst. Verbindungsstück ist die Spiegelung Kelms, die schemenhaft auf dem schwarzen Vinyl der Platte zu erkennen ist.

Wenn wir bei Verzeichnissen (Index), Camerae obscurae und ähnlichen Dingen sind, sollte man auch daran erinnern, dass Kelm weiterhin mit analoger Ausrüstung arbeitet, und zwar mit einer 4 × 5 Zoll Feld- oder Mittelformatkamera. Ihre C-Prints entwickelt sie alle selbst in der Dunkelkammer. Jede dieser Entscheidungen stellt sie in Widerspruch zur herrschenden Praxis der neueren, von digitaler Technik bestimmten Fotografie. Einen wichtigen Einblick in ihre Einstellung zu diesen Praktiken gibt eine Fotografie von 2009, *Untitled,* in der ein kleiner dreimastiger Schoner mit stolz im Wind wehenden Wimpeln an einem riesigen Containerschiff vorbeisegelt, dessen Länge auf beiden Seiten vom Bilderrahmen begrenzt wird. Auf der einen Seite also Standardisierung, gewerbliche Anonymität und Zeitgemäßheit. Dem entgegengesetzt: Handwerk, Idiosynkrasie und Anachronismus. Nicht ganz zufällig reisen die beiden Schiffe in entgegengesetzte Richtungen. Mit seinen Maßen von 61 × 91,8 Zentimetern ist das Werk eines der größeren in Kelms Œuvre, auch wenn es natürlich im Vergleich zu den Standards zeitgenössischer Fotografie – man denke an Vertreter der sogenannten „Becher Schule", unter anderen Andreas Gursky, Candida Höfer, Thomas Ruff und Thomas Struth – noch bescheiden ist. Diese Fotografen produzieren das, was Jean-François Chevrier als „Tableau-Form" bezeichnet, Bilder, die „für die Wand gestaltet und produziert werden und den Betrachter zu einem konfrontativen Erlebnis herausfordern, welches in scharfem Kontrast zu den gewohnten Prozessen steht, in denen fotografierte Bilder normalerweise gesehen und ‚konsumiert' werden".[9] Durch ihren Maßstab und ihre Größe sollen solche Bilder „die Wand dominieren" und eine Distanz zwischen Betrachter und Objekt schaffen, die derjenigen der Malerei gleicht. Wenn man als Betrachter vor einem solch großen Bild steht, muss man einige Schritte nach hinten gehen, um es ganz erfassen zu können. Laut Michael Fried ist dies „die entscheidendste Entwicklung im Aufstieg der neuen Fotografie", wobei er die „konfrontative Erfahrung" betont und den Abschied von konventionellen Modellen der Fotografierezeption, die auf kleinformatige Abzüge beschränkt waren. Soll heißen, dass vor den späten 1970er Jahren Fotos dazu gemacht wurden, aus der Nähe, also in Büchern, Zeitschriften, auf einer Seite, betrachtet zu werden. Die neue, große „Tableau-Form" aber wurde geschaffen, um an der Wand zu hängen.[10] In diesem Moment tritt das fotografierte Bild in Beziehung zum Betrachter und erbt auf

diese Weise, so Fried, all die Probleme, welche die Malerei bereits seit dem 18. Jahrhundert und seit Denis Diderot beschäftigen, also die gesamte Geschichte des Ringens von modernistischer Absorption mit antimodernistischer Theatralität.

Besonders in zwei Werken von 2008 hat Kelm ihre schwierige Beziehung zu den Werken von Bernd und Hilla Becher und deren Studenten ganz klar dargestellt – also zeitgleich mit Frieds Formulierung seiner spätmodernistischen Exegese der Tableau-Form. Eine Serie beschäftigt sich mit in Deutschland zwischen 1890 und den frühen 1930er Jahren in verschiedenen neotraditionellen, regionalen Stilen gebauten Holzhäusern, die oft als quasi-industrielle, vorgefertigte Architekturexperimente auftraten. Drei Fotografien zeigen zum Beispiel Häuser, die von der Wolgaster Holzindustrie Aktiengesellschaft hergestellt wurden, deren Fertighäuser für Ostseekurorte als klassische Beispiele der Bäderarchitektur des späten 19. Jahrhunderts gelten können. Gleichzeitig gehören sie zu den frühesten Beispielen von Fertighäusern in Deutschland überhaupt. Jens Hoffmann schreibt über diesen Werkkomplex, wie Kelm dadurch, „dass sie die Idee einer fertigen Form mit den utopischen Idealen modernistischer Architektur zusammenbringt, […] wohl die veränderte und vielleicht kompromittierte Stellung beider anmerkt".[11] Mag sein, auch wenn diese Lesart weniger überzeugt als die Interpretation dieser Serie als pointierte Entgegnung auf die Architekturfotografie der Becher-Schule; im Besonderen auf Thomas Ruffs die ikonische modernistische Architektur Ludwig Mies van der Rohes feiernde *L.M.V.D.R.*-Reihe (2000–2001). Kelm spielt hier ein sehr abgefeimtes Spiel, indem sie ziemlich traditionelle, oft ländliche, nichtsdestotrotz in ihrer Konstruktion sehr innovative Häuser fotografiert, während die von Ruff abgebildeten Häuser trotz ihrer geraden Linien und kubischen Formen meist das Produkt von ausgefeilter Handwerkskunst waren; in vergleichbarer Weise werden ihre relativ kleinen (die Wolgaster Abzüge messen alle ungefähr 77 × 60 Zentimeter), analogen Fotografien Ruffs viel größeren und digital manipulierten Bildern entgegengesetzt. Als die Arbeit, in der Kelm sich am deutlichsten mit den typologischen Anliegen der Bechers auseinandersetzt, kann der zwanzigteilige Zyklus *Caps* (2008) gelten. Dieser spiegelt deren industrielle Archäologien sehr genau wider, konzentriert sich hier aber auf die volkstümliche Form einer bizarren, von der Künstlerin in New Yorks Chinatown erworbenen, aus Bast gewebten Baseballkappe.

Kelms Verweis auf diese Tendenz der zeitgenössischen Fotografie – in gewisser Weise formten diese Werke ja den kritischen Horizont der Fotografie in den 1990er Jahren, als sie an der Hochschule für bildende Künste in Hamburg anfangs Malerei studierte – beschränkt sich keineswegs auf solch zwiespältige Zitate. Verschiedene Arbeiten scheinen sich der „absorbierenden" Qualität der Tableau-Form durch deutliche Heraufbeschwörung von Theatralität entgegenzustellen. Auf *Untitled* (2007) sehen wir die „Mighty Wurlitzer", die Ferdinand Werner von Siemens

1929 vom Hersteller erwarb und die jetzt im Musikinstrumenten-Museum in Berlin ausgestellt ist. Obwohl es die größte Orgel ihrer Art in Europa ist, zeigt Kelm nicht die mächtigen Pfeifen, die auf einer Galerie oberhalb des hier abgebildeten Raums stehen, sondern konzentriert sich stattdessen auf die Konsole aus weißem Lack in Form eines Hufeisens. Dieser Typus Orgel war als „Kinoorgel" (englisch „theater organ") bekannt und lieferte die musikalische Untermalung von Stummfilmen und kam später in Konzerten zum Einsatz. Man könnte also sagen, es handelt sich hier um ein Instrument, welches besonders deutlich auf seiner „Theatralität" beharrt. Fast verstohlen hat die Künstlerin auf der rechten Stütze eine Reproduktion eines Werks von Joan Miró platziert – während man natürlich die formale Harmonie der U-förmig geschwungenen Linien von Orgelkonsole und abstraktem Werk bemerkt, sollte man auch den implizierten Kontrast zwischen beispielhaft absorptivem Modernismus und theatralischer, ja fast schon kitschiger Qualität der Orgel bedenken. Die mit diesem Bild verwandte Arbeit *Seiler Meteorit Piano 116* (2007) internalisiert diese Spannung. Es ist eine Abbildung eines extravagant futuristischen Instruments, welches die honorige deutsche Klavierfabrik Seiler in den späten 1990er Jahren im Hinblick auf das nahende Millennium herstellte; hier soll man wohl die absorbierende Qualität des Musikhörens dem exzessiven, ja fast absurd extrovertierten Erscheinungsbild dieses Klaviers gegenüberstellen.

Frying Pan (2007), eines der bemerkenswertesten Arbeiten aus Kelms Œuvre, muss unbedingt zur Gruppe dieser Bilder gezählt werden. Wieder beschäftigen wir uns mit einem sehr besonderen Musikinstrument, diesmal einer elektrische Gitarre, vom Amerikaner George Beauchamp in den frühen 1930er Jahren erfunden. Hier sehen wir sie allerdings nicht in einem Museum, einem Aufnahme- oder Produktionsumfeld, sondern eher als eine Art Stillleben arrangiert, angelehnt an eine Wand, die mit einem Stoff bezogen ist, den die Künstlerin auf einem Pariser Markt fand und dessen Muster an ein Treppenbild von Escher erinnert. Frühere Betrachter lagen sicher nicht falsch, wenn sie in dem „afrikanisch gemusterten Stoff" ein Mittel sahen, die Gitarre in ein „anscheinend fremdes, afrikanisch aussehendes Musikinstrument" zu verwandeln.[12] Man sollte allerdings auch des komplexen räumlichen Spiels gewahr werden, welches dieses Bild in Bewegung setzt. Diese Gitarre hieß nicht nur aufgrund ihres runden Bauches und langen Halses „Bratpfanne", sondern auch wegen der Art und Weise, wie man auf ihr spielte: Man legte sie auf den Schoß und spielte im Sitzen. Trotz ihrer vertikalen Ausrichtung auf Kelms Bild codiert ihre Geschichte also eine horizontale Ausrichtung, die als Allegorie auf Kelms Ablehnung der Tableau-Form gelesen werden kann – im Gegensatz zum modernen Bestreben, die „Wand zu dominieren", ist Kelm bestrebt, eine andere, ältere Form der Fotografiebetrachtung zu erhalten, dem Lesen einer Seite verwandt. Sie besteht darauf, *Frying Pan* gekippt zu zeigen, was dem Betrachter den nötigen

Hinweis auf das Spiel mit der Orientierung gibt. Auch der Stoff trägt seinen Teil zur räumlichen Ambiguität bei. Das erste Mal taucht er (genau wie diese Art von arrangiertem Stillleben überhaupt) in *Target Record* und *After Lunch Trying to Build Railway Ties* (beide 2005) auf. Hier begegnen wir ihm zum zweiten Mal, aber es sollte noch bis 2009 und 2010 dauern, bis die Künstlerin das Potenzial dieser Stoffe voll ausnützen würde, zuerst in *Venice Zurich Brussels* (2009) und dann in *Untitled* (2010), in dem unsicher aufgestellte Spielkarten auf einem verwirrenden, mit sich wiederholenden Pokersets gemusterten Stoff ruhen. Auf all diesen Bildern dient der Stoff dazu, den Horizont zu verschleiern oder gar ganz zu eliminieren, wodurch die Komposition radikal verflacht wird und alle Anhaltspunkte zur Tiefe des Bildes grundsätzlich durcheinandergewirbelt werden. Es wird schwierig, den Maßstab zu ermessen, und der am Lot ausgerichtete Raum, den man auf Fotografien zu finden gewohnt ist, weicht einer analogen, improvisierten Version von bildschirmhafter Flachheit und den dazugehörigen Technologien und digitalen Manipulationen, von denen Kelm sich abgewandt hat. Während also Kritiker (durchaus ermuntert von der Künstlerin) den Ursprung ihres Interesses an diesen Musikinstrumenten „in ihrem Grenzstatus an der Spitze neuer Technologien, ähnlich einem zeitgenössischen Fotografen" begründet sehen, sollte man darin vielleicht eher ein komplexeres *Spiel* mit den Kodizes der Digitalisierung und der Tabelau-Form anstatt reine Ablehnung erkennen.[13]

Dies ist nirgends deutlicher artikuliert als in ihrer Serie *Big Print* (2007), deren Titel nicht nur an den vordergründigen Gegenstand der Werke gemahnt – eine von der Innenarchitektin Dorothy Draper in den 1940er Jahren für Schumacher produzierte Stoffkollektion –, sondern der auch einen schlauen Seitenhieb auf die Größenthematik in der zeitgenössischen Fotografie bedeutet, so wie sie von Chevrier und Fried herausgestellt worden ist. Hierbei muss man bedenken, dass diese mit nur ungefähr 130 × 100 Zentimetern Kelms größte Werke sind. Anders als die vorher erwähnten Werke, in denen die Stoffe nur Hintergrund in einem auf einem Tisch arrangierten Stillleben sind, wird in dieser Serie der Stoff aus Frontalansicht und ganz flach fotografiert. Der Abzug reproduziert den Stoff dann auch noch in Originalgröße. André Rottmann bemerkt, wie „ihre sich dauernd wiederholenden Muster an das Greenberg'sche Ideal der mediumspezifischen Malerei erinnern, die sich nur auf die Frage der Optik und der Fläche konzentriert". Wie so viele andere Rezipienten von Kelms Arbeiten will er einen rein äußerlichen Kommentar zur Verschmelzung von hoch und niedrig in diesen Bildern erkennen, von „der allumfassenden Ästhetisierung des Alltags" und „künstlerischem Modernismus", eine Dynamik, die von jeder objektiven Untersuchung zeitgenössischer Sehkultur als hinfällig erklärt werden müsste.[14] Kelm interessiert sich nicht so sehr dafür, den schon lange anerkannten Zusammenfall von hoher Kunst und Massenkultur aufzuzeigen – sie zielt hier nicht einfach auf die Ideologie des Modernismus –, sondern sie ist vielmehr darauf aus,

sich auf die rein zeitgenössische Tendenz in der Fotografie zu beziehen, sehr große Abzüge mit einem erlösenden spätmodernistischen Konzept der Absorption gleichzusetzen. Hier präsentiert sie uns also den „big print", der uns aber trotzig als starkes Muster aus Drapers „modernem Barock"-Stil entgegentritt. Vielleicht fühlt man sich hier an einige von Gurskys abstrakteren Arbeiten erinnert, so zum Beispiel sein *Untitled XV* (2005), ein von oben geschossenes Bild, das Arbeiter beim Verlegen von Rollrasen auf einem Fußballfeld zeigt. Trotz seiner stark repetitiven Muster wird die Aufmerksamkeit des Betrachters hier aber immer wieder auf die visuellen Abnormalitäten gelenkt, die kleinen Zwischenfälle, die dieses dekorative Arrangement unterbrechen. Anders gesagt zieht Gursky uns ins Bild hinein, während Kelms *Big Print* auf nichts anders besteht als auf seiner ornamentalen Oberfläche.

Sie nähert sich der post-Becher'schen Tableau-Form demnach also nicht mit absoluter Ablehnung, sondern durch eine Art von subversiver Performance von deren Kodex. Man könnte vielleicht sagen, sie bezieht sich auf ein untergeordnetes Element dieser Ästhetik, das, was Norman Bryson die „Gegenpräsenz" oder „negative Aufmerksamkeit" genannt hat, die auf vielen Ebenen der Fried'schen Absorption widerspricht. Für Bryson brechen die Bechers und ihre Studenten mit dem in der klassischen Fotografie herrschenden Paradigma der Anwesenheit, bei dem „die fotografische Oberfläche als Informationsreservoir diente, auf das die Blicke in einem relativ konstanten und gleichmäßigen Prozess der Aufnahme gezogen wurden, angefangen von den auffallendsten Gebilden bis hin zur den kleinsten Details". Anders ausgedrückt war die Fotografie immer „eindeutig gewollt, auf den Betrachter ausgerichtet", wobei die Fülle ihrer Bedeutung darauf wartete, vom Blick des Betrachters geradezu gierig getrunken zu werden.[15] Die von den Bechers eingeläutete konzeptuelle Richtungsänderung hat diesen Blick blockiert: „Gegenpräsenz dreht sich ganz um das Ungewollte, um Abfälschung und Rückzug." Dabei wird der reibungslose Ablauf der Absorption von einer Lücke unterbrochen, die „den Fluss durchteilt und den Blick schon in seinen Anfängen aufhält". Im Falle der Bechers wird dies durch eine kategorisierende Operation erreicht, die es erzwingt, dass Bedeutung im Vergleich von Bildern zum Vorschein kommt. Das Auge wird nicht mehr als passiver Empfänger von Flüssen visueller Information angesehen, sondern muss jetzt Bedeutung aus Gegenüberstellung und Fragmentierung destillieren.[16] Diese Gegenpräsenz wird in verschiedenen von uns schon untersuchten Serien in Kelms Werk ausdrücklich aktiviert, so in *Wolgaster Holzindustrie Aktiengesellschaft* (2008) und in *Caps* aus demselben Jahr wie auch in neueren Arbeiten, zum Beispiel der vierteiligen Arbeit *Untitled* (2009), auf der ein Sonnenblumenfeld zu sehen ist, *Untitled* (2010), mit seinem immer wieder andersherum gezeigten rot-weiß karierten Tischtuch samt Label, oder dem Doppelporträt *Anna #2* (2011). In Wirklichkeit aber ist das die Dynamik, die in Ihrem Werk als Ganzem am Werke ist – der paradoxe Zustand der negativen

Aufmerksamkeit liegt der interpretativen Unsicherheit, mit der man anfängt, zu Grunde: Obwohl nichts verborgen bleibt, ist der Sinn des Bildes doch nicht in dem zu finden, was uns vor Augen steht.

Kelms Kollegin Lisa Oppenheim nennt es einfach: unheimlich.[17] Damit spielt sie auf die Tatsache an, dass Kelms Fotografien gerade in ihrer Vertrautheit irgendwie verstörend sind. Man findet aber nur relativ wenige Arbeiten, in denen die mit diesem psychoanalytischen Tropus assoziierte Unheimlichkeit aufgenommen wird. Wenn doch, so wie in *House on Haunted Hill I (night)* und *II (day)* (beide 2005), zwei Aufnahmen von Frank Lloyd Wrights Ennis House, dann nur als Anspielung auf Vincent Prices kitschigen Thriller *House on Haunted Hill* von 1959 (Regie: William Castle), dessen Außenaufnahmen dort entstanden. Allerdings ist diese sich selbst bewusste Abseitigkeit, die man zum Beispiel mit dem Interesse der Surrealisten am Unheimlichen verbindet, nicht wirklich das, wovon Oppenheim hier spricht; das halb verfallene Haus ist schließlich auch nicht repräsentativ für die Arbeiten der Künstlerin. Vielmehr geht es ihr um die Art und Weise, in der Objekte durch Wiederholung denaturalisiert werden, so wie das sich wiederholende Ziffernblatt in *Anonymous, Lilac Clock Bag Buffalo Exchange* (2007). Der Titel bezieht sich hier sowohl auf das, was auf den Bildern zu sehen ist, als auch darauf, wo dieses gekauft wurde, eine Ladenkette namens Buffalo Exchange, in der es Secondhandkleider gibt. „Anonymous" bedeutet wahrscheinlich, dass der Käufer es vorzog, unerkannt zu bleiben. Re-Iteration und Dekontextualisierung verwandeln hier dies an sich banale Objekt und verleihen ihm eine Art von bildhauerischem Drama, das sich sehr unterscheidet von dem Objet trouvé – nicht zuletzt handelt es sich bei Buffalo Exchange ja nicht um einen Pariser Flohmarkt, den typischen Jagdgrund der Surrealisten bei ihrer Suche nach dem Unheimlichen und Wundersamen. Und auch wenn Kelms Uhrentasche, ein klassisches 1980er-Jahre-Design von Marilyn Brooks aus Toronto, ein bisschen aus der Mode gekommen sein sollte, so kann man doch nicht sagen, sie sei hinfällig oder komplett unmodern, genau wie sonst das Objet trouvé, werden doch genau diese Taschen von einer bestimmten Art ironisch eingestellter Hipster heiß begehrt. Am ehesten ähneln ihre Aufnahmen vielleicht noch den auf Stilblogs oder Auktionswebseiten geposteten Schnappschüssen solcher Taschen. Indem sie die Uhrzeit, die in Uhrenwerbungen am öftesten auftaucht (10:10), kaum merklich verändert – auf jedem Bild ist der große Zeiger ein bisschen weitergekrochen –, zeigt sie ein akutes Bewusstsein des so einem Wertobjekts angemessenen Protokolls und lässt das Bild auf subtile Weise vom Ideal abweichen.[18]

Dies alles lässt allerdings die Frage offen, warum Kelm für sich ausgerechnet dieses kritische Terrain abgesteckt hat. Beshty, der die Tendenz ihrer Arbeiten zum Antiklimax bemerkt hat, nennt ihre Arbeiten eine „kleine Fotografie" in Anlehnung an Gilles Deleuze und Félix Guattari und ihre Idee einer „kleinen Literatur": „[K]eine ihrer Serien geht über einige wenige Iterationen hinaus und ihre Gegenstände [...] sind ganz klar nicht das Arbeitsfeld eines Taxonomen oder der allegorische Abfall eines Sozialrealisten", auch wenn „deren Handwerkszeug durchscheint". Ihre Welt ist eine von „sich verschiebenden Bedeutungen und Anspielung", eine, die „innerhalb zur Ausschließlichkeit verpflichtender Strukturen auf sich selbst anspielt, und diese so dem Vorübergehenden und Eventuellen verpflichtet".[19] Ich halte das für die bei Weitem zutreffendste uns zur Verfügung stehende Beschreibung von Kelms Arbeiten. Trotzdem bleibt die Frage, wodurch Kelm eigentlich Zugang zu dieser kleinen Sprache findet. Betrachtet man ihre Arbeiten, so liegt nahe, dass die Antwort zumindest teils mit Gender-Befindlichkeiten zu tun hat, mit der bekümmernden Rolle, die der weiblichen Identität innerhalb der wichtigsten Kulturkategorien immer noch zufallen kann. In manchen Fotografien der Künstlerin finden sich hierfür auf jeden Fall Hinweise, am deutlichsten vielleicht in *After Man Ray* (2005), auf der ein nur mit einem seltsam ausgeschnittenen schwarzen, den Oberkörper größtenteils freilassenden Textil bekleideter junger Mann seinen rechten Arm in einer Geste der Exponiertheit und visuellen Verfügbarkeit über seinen Kopf legt, einer Geste also, die man normalerweise mit Abbildungen weiblicher Akte verbindet. Er ist glatt rasiert, nur seine Oberlippe ziert ein kruder schwarzer Schnurrbart, dessen Künstlichkeit durch die braunen Haare des Mannes erst recht herausgestellt wird und der allem Anschein nach auf den Abzug gemalt worden ist. Wegen des Titels des Bildes assoziiert man den amerikanischen Fotografen Man Ray, obwohl Kelms Fotografie an keine seiner Kompositionen anmutet; höchstens könnte man sagen, dass der Bart eventuell eine Reprise der von Ray auf ein Bild seines Models Kiki in *Le Violin d'Ingres* (1924) gemalten F-Schlüssels ist. Immerhin ist die Technik identisch und die Form ähnlich. Der Bildtitel ist eigentlich aber irreführend, denn *After Man Ray* ist eher ein Zitat von Maurice Tabards *Nude* (1929): Kelm hat die Schatten aus Tabards Bild einfach in die Form des von ihrem Modell getragenen rudimentären Oberteils übertragen – nicht ohne in entscheidender Weise die junge Frau durch einen jungen Mann ersetzt zu haben.

Für diese Künstlerin sind die Übertragungen in *After Man Ray* ungewohnt greifbar, wodurch es zu einem im Vergleich zu ihren übrigen Arbeiten relativ expliziten Statement wird. „Ich fände es langweilig, wenn ein Foto nur eine Interpretation zuließe ... Ein Bild zu machen, das sich nur mit Genderidentität beschäftigt, wäre viel zu dogmatisch", sagte Kelm im Zusammenhang mit ihrem bekannten Bild eines einen offenen Fächer haltenden Cowboys, welches oft als Hinterfragung der dieser Figur anhaftenden Männlichkeitsklischees verstanden wird.[20] In der Tat soll die Diskussion von Genderrollen hier auf keinen Fall unterstellen, dass sich Kelm einer bestimmten politischen Agenda verpflichtet hat oder sich bewusst mit dem Feminismus und seinen Spuren in der zeitgenössischen Kunst identifiziert. Weiblichkeit taucht

in Kelms Arbeiten eher auf als dezenter Bezug zu Frauen, deren kultureller Beitrag marginalisiert wurde, so wie in der vorher besprochenen *Big Print*-Serie mit ihren Zitaten von Drapers Textilien oder in *Untitled* (2007), das ein Hameau oder „Dörfchen" zeigt, welches in ländlichem Stil für Marie Antoinette in Versailles aufgebaut worden war. In keiner dieser Arbeiten steht das Geschlechterverhältnis irgendwie im Vordergrund; stattdessen werden wir mit Beispielen konfrontiert, in denen die weibliche Identität die Grandiosität männlicher Wichtigtuerei unterläuft. So, wie das bei den *Big Prints* funktioniert, ist es auch in *Untitled:* Das Hameau mit seinen kleinen Maßstäben und seiner Ländlichkeit war als Refugium vor dem überwältigend formalen Hofleben in Versailles gedacht, was wiederum als eine weitere Allegorie auf Kelms eigene Beziehung zur herrschenden fotografischen Praxis verstanden werden kann. Das bei Weitem eindeutigste Statement zu diesem Thema findet man in *Your House is my Castle* (2005), das die Künstlerin selbst, geschmückt mit falschem Bart, im manierierten Garten des im 16. Jahrhundert erbauten Casa Storta (Schiefes Haus) in Bomarzo in der Nähe Roms zeigt. Kelm fügt sich selbst in diese seltsame – von den Surrealisten so geschätzte – Umgebung ein und nimmt sie für sich in Anspruch, womit sie, indem sie dieses Haus selbst besetzt, den englischen Spruch „A man's house is his castle" herausfordert. Die Tatsache, dass der Garten von Pier Francesco Orsini zu Ehren seiner verstorbenen Gattin Giulia Farnese, angelegt worden war, verstärkt diese Geste nur: von der Muse zur Hausbesitzerin, oder zumindest Hausbesetzerin. Dieser für Kelms „relativ androgynes Werk" so typische Zug ist bis jetzt die witzigste Zusammenfassung ihrer destabilisierenden Rolle in der zeitgenössischen Fotografie, in der sie sich in vorherrschende Formen einarbeitet, nur um sie dann von innen heraus in Frage zu stellen.[21]

1 Beatrix Ruf in: „Susanne Pfeffer, Beatrix Ruf and Nicolaus Schafhausen in Conversation", in: *Annette Kelm,* Susanne Pfeffer, Beatrix Ruf und Nicolaus Schafhausen (Hrsg.), Koenig Books, London, 2009, S. 64.
2 Michaela Meise, „Sur pointes", in: *Annette Kelm: Errors in English,* Koenig Books, London, 2006, S. 53.
3 Ruf in: „Susanne Pfeffer, Beatrix Ruf and Nicolaus Schafhausen in Conversation", a. a. O., S. 62.
4 Bernard Edelman, *Ownership of the Image,* Routledge & Kegan Paul, London, 1979, S. 37–67.
5 Auf die Ähnlichkeiten mit der Falknerei wird in Beatrix Ruf, „Twisting and Turning", in: *Parkett* 87, März 2010, S. 156, verwiesen.
6 Walead Beshty, „Toward a Minor Photography: Annette Kelm's Discrete Cosmologies", in: *Parkett* 87, März 2010, S. 161. Die Zielscheibenthematik ist schon von einigen Kritikern rezipiert worden, so zum Beispiel bei Sabeth Buchmann, „Mistakes are a question of language", in: *Annette Kelm: Errors in English,* a. a. O., S. 15–17, und bei Mac Giolla Léith, „Target and Record", in: *Annette Kelm,* a. a. O., S. 59–65.
7 Daisetz T. Suzuki, „Introduction", in: Eugen Herrigel, *Zen in the Art of Archery,* Vintage Books, New York, 1989, S. VIII.
8 Mac Giolla Léith, „Target and Record", a. a. O., S. 63.
9 Jean-François Chevrier, „The Adventures of the Picture Form in the History of Photography", in: Douglas Fogle, *The Last Picture Show,* Walker Art Center, Minneapolis, 2003, S. 116.
10 Michael Fried, *Why Photography Matters as Art as Never Before,* Yale University Press, New Haven und London, 2008, S. 143.

11 Jens Hoffmann, „Sculptural Moments", in: *Passengers: Annette Kelm,* CCA Wattis Institute for Contemporary Art, San Francisco, 2008, o. p.
12 Ebd.
13 Mac Giolla Léith, „Target and Record", a. a. O., S. 61, Fn. 12.
14 André Rottmann, „Annette Kelm: Galerie Johann König", in: *Artforum* 46, Nr. 4, Dezember 2007, S. 367.
15 Norman Bryson, „From Form to Flux", in: *Sharon Lockhart,* Museum of Contemporary Art, Chicago, 2001, S. 82 und 84. Kirsty Bell bezieht sich in ihrer Interpretation von Kelms Arbeiten auch auf Brysons Idee der „Gegenpräsenz". Siehe hierzu Kirsty Bell, „Focus: Annette Kelm", in: *Frieze* 113, März 2008, S. 24.
16 Bryson, „From Form to Flux", a. a. O., S. 84, 82.
17 Lisa Oppenheim, „Annette Kelm, A precise, wideranging scavenger", in: *Flash Art* 271, März/April 2010, S. 84.
18 Von Susanne Pfeffer so beobachtet in: „Susanne Pfeffer, Beatrix Ruf and Nicolaus Schafhausen in Conversation", a. a. O., S. 63.
19 Walead Beshty, „Toward a Minor Photography", a. a. O., S. 162.
20 Zitat von Annette Kelm in Tim Ackermann, „Cold, Clear Pictures: Annette Kelm's Conceptual Photo Works", in: *db artmag,* 2008, abrufbar unter: http://db-artmag.de/archiv/2008/e/4/2/617.html.
21 Die Charakterisierung als „androgyn" stammt von Zoë Gray in: Zoë Gray, „Sense and Sensibility: Pleasure, Pattern, and the Picture Plane", in: *Annette Kelm,* a. a. O., S. 68.

All works are framed C-prints

3–5 J'aime Paris, 2013
3 parts, each 76.5 × 60.5 cm /
78.2 × 62.3 cm

7 Soles, LOL!, C U SOON, XO,
STUFF 2 DO, 2013
77.4 × 60.7 cm / 79.3 × 62.5 cm

8 Materialtest, 2011
51 × 60 cm / 68.5 × 77 cm

9 Untitled (Portrait on a Ladder),
2009
50 × 38 cm / 71.5 × 59.7 cm

11 Untitled, 2010
49.8 × 61.7 cm / 51.5 × 63.5 cm

13 Untitled (Cards), 2010
68.3 × 84.1 cm / 70.3 × 86 cm

15–17 Untitled, 2012
3 parts, 61.9 × 50.1 cm,
49.8 × 40.2 cm, 39.9 × 32.1 cm /
63 × 51 cm, 51 × 41 cm, 41 × 33 cm

19 Untitled, 2012
69.4 × 61.9 cm / 70.7 × 63.2 cm

20 Untitled (Horseshoe Magnets 2),
2012
69.2 × 56.2 cm / 70.5 × 58 cm

21 Bouquet, 2012
80 × 67.7 cm / 82.3 × 70 cm

23 Untitled (Boats), 2009
61 × 91.8 cm / 62.5 × 93.5 cm

24–25 Anna #1, 2011
2 parts, each 52 × 42 cm /
69.8 × 60.3 cm

27 Iron Filings, Smile, 2013
27.7 × 29 cm / 44.2 × 38 cm

28 Untitled, 2012
60.3 × 49.8 cm / 61.4 × 50.9 cm

29 Untitled, 2012
62.9 × 50.9 cm / 64 × 52 cm

31 Untitled, 2012
58.3 × 48.3 cm / 59.4 × 49.4 cm

32 Untitled, 2012
62.4 × 49.9 cm / 63.3 × 51 cm

33 Untitled, 2012
62.2 × 49.2 cm / 63.3 × 50.3 cm

35 Vitrine zur Geschichte der
Frauenbewegung in der Bundesrepu-
blik Deutschland, Deutsches
Historisches Museum, Berlin, 2013
78.7 × 60.8 cm / 80.6 × 62.5 cm

36 Paisley and Wheat Pink, 2013
58.5 × 46.7 cm / 60 × 48.1 cm

37 Paisley and Wheat Red, 2013
59 × 42.8 cm / 60.4 × 44.1 cm

38 Paisley and Wheat Medium Gray,
The Standard, 2013
65 × 47 cm / 66.4 × 48.2 cm

39 Paisley and Wheat, Orange #1,
2013
61 × 45.5 cm / 62.4 × 46.9 cm

40 Vitrine zur Geschichte der
Frauenbewegung in Baden-Württem-
berg, Haus der Geschichte
Baden-Württemberg, Stuttgart, 2013
78 × 62.5 cm / 80.5 × 65 cm

41 Vitrine zur Geschichte der
Frauenbewegung in der Bundesre-
blik Deutschland, Stiftung Haus
der Geschichte der Bundesrepublik
Deutschland, Bonn, 2013
67.8 × 52.8 cm / 70.5 × 55.5 cm

43 Untitled (Tribal), 2010
56.5 × 44 cm / 76 × 63.5 cm

45–47 Sale, 2010
3 parts, each 40.9 × 50.3 cm /
42 × 51.5 cm

48 Latzhose 3, "Kicking Leg", 2014
63 × 77.5 cm / 79.5 × 64.8 cm

49 Latzhose 1, "Relaxed", 2014
65 × 79.5 cm / 81.2 × 66.8 cm

50 Ivy, 2013
31.2 × 23.7 cm / 32.4 × 24.9 cm

51 Erich Mendelsohn Hat
Manufacture Building Friedrich
Steinberg, Herrmann & Co,
Luckenwalde (1921–1923), 2013
24.5 × 30 cm / 39.4 × 45.2 cm

53 Badisches Landesmuseum
Karlsruhe Vitrine „80er Jahre",
Dauerausstellung, 2014
60.6 × 77.9 cm / 80.4 × 62.4 cm

54 Art Car #2, 2010
65.6 × 81.2 cm / 67.5 × 83 cm

55 Untitled, 2011
92 × 70 cm / 95 × 73.5 cm

57 Yellow (Paisley), 2010
43.7 × 35.6 cm / 64.3 × 56 cm

58 Espadrilles, U R MY BFF, LOL!,
HOW R U?, 2013
77.3 × 63.7 cm / 79.1 × 65.6 cm

59 Espadrilles, 2 GOOD 2 BE TRUE,
TTYL, XO, HOW R U?, 2013
79 × 63.5 cm / 80.8 × 65.3 cm

60–61 Percent for Art, 2013
6 parts, each 70 × 50 cm /
72.3 × 50.5 cm

62–63 Anna #2, 2011
2 parts, each 42 × 52 cm /
60.3 × 69.8 cm

65 Papierzylinder, 2011
60 × 50 cm / 77.8 × 66.8 cm

66–67 Institut für Zeitgeschichte –
Archiv, Bestand Hannelore Mabry/
Bayerisches Archiv der Frauen-
bewegung, Signatur ED 900, Box 403
Nr. 2. Körperüberhang: „Weder rot
noch tot: gewaltlos für den Feminis-
mus kämpfen!" / „Mit Bertha von
Suttner – Die Waffen nieder! Dafür
kämpft DER FEMINIST", 2014
2 parts, each 86.3 × 78.5 cm /
87.8 × 80 cm; with the support of the
Espace Louis Vuitton, Munich

68–69 Institut für Zeitgeschichte –
Archiv, Bestand Hannelore Mabry /
Bayerisches Archiv der Frauenbewe-
gung, Signatur ED 900, Box 526.
Körperüberhang: „Frau Carrar und
die Gewehre – Nicht Brecht Frau
Carrar hatte Recht – Gewehre
gehören vergraben! Das letzte Wort
der Mutter dem Patriarchen nicht!" /
„Frau Carrar und die Gewehre –
Nicht Brecht Frau Carrar hatte Recht –
Gewehre gehören vergraben!
Das letzte Wort der Mutter dem
Patriarchen nicht!", 2014
2 parts, each 84.7 × 76.2 cm /
87.7 × 76.2 cm; with the support of
the Espace Louis Vuitton, Munich

70–71 Institut für Zeitgeschichte –
Archiv, Bestand Hannelore Mabry /
Bayerisches Archiv der Frauen-
bewegung, Signatur ED 900, Box 403.
Nr. 7. Körperüberhang: „Frauen
Mütter Feministen kämpfen für Abrüs-
tung und Entwaffnung aller Länder" /
„Wir fordern Abrüstung bis zum
Küchenmesser", 2014
2 parts, each 86 × 77 cm /
89.3 × 79.8 cm; with the support of
the Espace Louis Vuitton, Munich

72–73 Institut für Zeitgeschichte –
Archiv, Bestand Hannelore Mabry /
Bayerisches Archiv der Frauen-
bewegung, Signatur ED 900, Box 531.
Körperüberhang: „Keine Mark,
kein Dollar, kein Rubel für Waffen!
DER FEMINIST" / „Menschenrecht
statt Männerrecht", 2014
2 parts, each 84.8 × 76.4 cm /
88 × 80 cm; with the support of the
Espace Louis Vuitton, Munich

75 Horseshoe Magnet, 2011
50 × 44 cm / 70 × 63 cm

76–77 Magnolia #1, 2011
2 parts, 60 × 50 cm, 52 × 40 cm /
77.5 × 65.3 cm, 69.3 × 58.5 cm

79 Untitled, 2013
54.5 × 44 cm / 55.5 × 45.5 cm

80 Untitled, 2013
41 × 51 cm / 42.5 × 52.5 cm

81 Arles, 2012
72.5 × 59 cm / 74.3 × 60.8 cm

82–83 Untitled, 2013
65 × 80 cm / 66 × 81.5 cm

85 Untitled, 2011
69.8 × 56.5 cm / 72.3 × 58.8 cm

86–87 Strawflowers, 2013
3 parts, each 81 × 65.3 cm /
84 × 68.3 cm

88–90 Michaela Coffee Break,
2009
3 of 6 parts, each 43 × 32 cm /
64.5 × 43.7 cm

91 Venice, Zurich, Brussels, 2009
58.8 × 67.7 cm / 60.4 × 69.3 cm

93 Dove, Kurfürstendamm, 2013
72 × 33.5 cm / 73.4 × 34.9 cm

94–96 Michaela Coffee Break,
2009
3 of 6 parts, each 43 × 32 cm /
64.5 × 43.7 cm

97 Untitled, 2012
60 × 46 cm / 61.5 × 47.5 cm

99 Untitled (Cardboard, Paisley,
Close Up), 2013
87.3 × 61 cm / 90.3 × 64 cm

100 Untitled (Cardboard, Paisley,
Ladder), 2013
87.5 × 69.2 cm / 90.5 × 72.2 cm

101 Untitled (Cardboard, Paisley,
Ladder, Hands), 2013
88 × 71.2 cm / 91 × 74.2 cm

Reference illustrations on page 114

Turning into a Parrot, 2003
50 × 40 cm / 67.7 × 59 cm

I Love the Little Baby Giant Panda,
I'd Welcome One to My Veranda,
2003
40 × 50 cm / 60 × 70 cm

Big Print #2 (Maui Fern – Cotton
"Mainsail Cloth" Fall 1949
Design Dorothy Draper, Courtesy
Schumacher & Co), 2007
131.5 × 100.5 cm / 133 × 103 cm

Target Record, 2005
35 × 45 cm / 56.6 × 66.7 cm

Untitled, 2005
80 × 100 cm / 82.5 × 101.5 cm

Frying Pan, 2007
100.5 × 80 cm / 104.5 × 81.5 cm

Presentation House Gallery
Staff / Mitarbeiter

Director and Curator /
Direktor und Kurator:
Reid Shier

Curator / Kuratorin:
Helga Pakasaar

Campaign Director / Projektleiterin:
Jessica Bouchard

Gallery Manager / Galeriemanagerin:
Diane Evans

Development and Communications
Manager / Leiterin Entwicklung und
Kommunikation:
Vanessa Sorenson

Preparator / Ausstellungsaufbau:
Erik Hood

Financial Controller / Finanzcontroller:
Robyn Browes

Gallery Assistants / Galerieassistenten:
Miriam Kleingeltink, Justin Ramsey

Board of Directors / Vorstand

Paula Palyga
(President / Vorsitzende)
Cheryl Stevens
(Former President / Frühere
Vorsitzende)
David Sprague
(Vice President / Stellvertretender
Vorsitzender)
Doug Allan
(Treasurer / Schatzmeister)
Iain Mant
(Secretary / Schriftführer)
Christian Chan
Pauline Hadley-Beauregard
Kevin Pike
Cindy Richmond
George Seslija
Sam Whiffin

Presentation House Gallery
333 Chesterfield Avenue
North Vancouver, BC, V7M 3G9
Canada
www.presentationhousegallery.org

Supported by / Förderung

Canada Council for the Arts
British Columbia Arts Council
Province of British Columbia
The City of North Vancouver
and the District of North Vancouver
through the North Vancouver
Recreation & Culture Commission
Yosef Wosk Foundation

Kölnischer Kunstverein
Staff / Mitarbeiter

Director and Curator /
Direktor und Kurator:
Moritz Wesseler

Curator / Kuratorin :
Carla Donauer

Managing Director / Geschäftsführerin:
Marianne Walter

Assistant to the Managing Director /
Assistentin der Geschäftsführerin:
Lina Rehs

Technician / Haustechniker:
Uwe Becker

Preparators / Ausstellungsaufbau:
Robert Brambora, David
Gaupp-Maier, Fabian Kuntzsch,
Maik Prus

Reception / Empfang:
Anna Katharina Lahr, Elmas Senol,
Linda Stahnke, Beate Wester

Board of Directors / Vorstand

Dr. Thomas Waldschmidt
(President / Vorsitzender)
Stephanie Schwarze
(Vice President / Stellvertretende
Vorsitzende)
Ulrike Remde
(Treasurer / Schatzmeisterin)
Prof. Dr. Rainer Jacobs
(Secretary / Schriftführer)
Johannes Becker
Nicola Bscher
Daniel Buchholz
Christian DuMont Schütte
Andreas Hecker
Lars Heller
Franz König
Alexander Köser
Heike van den Valentyn

Kölnischer Kunstverein
Hahnenstraße 6
50667 Köln
Germany
www.koelnischerkunstverein.de

Supported by / Förderung

Stadt Köln
Kunststiftung NRW

With thanks to / Mit Dank an

Viola van Beek, Isabelle Belting, Carlo
Bronzini, Eileen Cohen, Courtney
and/und David Corleto, Bice Curiger,
Carla Donauer, Rebecca and/und
Martin Eisenberg, Ute Elbracht,
Isabelle Fein, Hadley Martin Fisher,
Marc Foxx, Brigitte and/und Henning
Freybe, Isabelle Graw, Katharina
Grosse, Sarah Haugeneder, Brigitte
Heck, Laura Hegewald, Jens Hoffmann,
Peter Hoffmann, Jane Irwin and/und
Ross Hill, Rodney Hill, Taka Ishii, Anja
Kaehny, Renate Kainer, Timo Kapeller,
Casey Kaplan, Helga and/und
Gerhard Kelm, Susanna Kirschnick,
Johann König, Andrew Kreps, Dr. Klaus
Lankheit, Aram Lintzel, Dirk von
Lowtzow, Gió Marconi, Erika Maurer,
Christian Mayer, Tom McDonough,
Michaela Meise, Dr. Matthias Mühling,
Helen and/und John O'Brian, Esther
Quiroga, Sabine Reitmaier, Christiane
Rothe, Beatrix Ruf, Pamela and/und
Arthur Sanders, Michael Schmidt, Elisa
Schroer, Hendrik Schwantes, Reid
Shier, Jerry Speyer, Claudia and/und
Kurt von Storch, Iris Ströbel, Christina
Végh, Anna Voswinckel, Haig Walta,
Moritz Wesseler, Thea Westreich and/
und Ethan Wagner, Cosima Wolter,
Deane and/und Lorrin Wong

This catalogue is published on the occasion of the exhibitions / Diese Publikation erscheint anlässlich der Ausstellungen:

Annette Kelm
8.9.–14.10.2012
Presentation House Gallery

Annette Kelm – Staub
7.11.–21.12.2014
Kölnischer Kunstverein

Editor / Herausgeber:
Kölnischer Kunstverein /
Presentation House Gallery

Design / Gestaltung:
Heimann und Schwantes

Lithography / Lithografie
Print / Druck:
DruckConcept
Kirchner & Rothe GmbH

Translation / Übersetzung:
Benita Goodman, Gerrit Jackson,
Klaus Roth, Michael Wetzel

Copy-Editing / Lektorat:
Nathan Moore, Viola van Beek

Texts / Texte:
Interview/Gespräch Isabelle Graw
with/mit Annette Kelm on/am
9.5.2013, Tom McDonough, Reid
Shier, Moritz Wesseler

All pictured works / alle
abgebildeten Werke courtesy the
artist / die Künstlerin and/und
Johann König, Berlin
Andrew Kreps Gallery, New York
Gió Marconi, Milan
Taka Ishii Gallery, Toyko
Marc Foxx Gallery, Los Angeles
Galerie Mayer Kainer, Vienna
Herald St, London

Published by / Erschienen im
Verlag der Buchhandlung
Walther König, Köln,
Ehrenstraße 4, 50672 Köln

Bibliographic information published
by the Deutsche Nationalbibliothek:
The Deutsche Nationalbibliothek
lists this publication in the Deutsche
Nationalbibliografie; detailed bib-
liographic data are available in
the Internet at http://dnb.d-nb.de. /
Bibliografische Information der
Deutschen Nationalbibliothek:
Die Deutsche Nationalbibliothek
verzeichnet diese Publikation in der
Deutschen Nationalbibliografie;
detaillierte bibliografische Daten sind
über http://dnb.d-nb.de abrufbar.

Library and Archives Canada
Cataloguing in Publication information:
http://presentationhousegallery.org/
product/annette-kelm-phg/

Printed in Germany

Distribution / Vertrieb

Germany & Europe /
Deutschland & Europa:
Buchhandlung Walther König, Köln
Ehrenstraße 4, 50672 Köln
Tel. +49 (0) 221 / 20 59 6-53
Fax +49 (0) 221 / 20 59 6-60
verlag@buchhandlung-walther-
koenig.de

UK & Ireland Cornerhouse /
Großbritannien & Irland:
Publications 70 Oxford Street
GB-Manchester M1 5NH
Fon +44 (0) 161 200 15 03
Fax +44 (0) 161 200 15 04
publications@cornerhouse.org

Outside Europe /
Außerhalb Europas:
D.A.P. / Distributed Art
Publishers, Inc.
155 6th Avenue, 2nd Floor
USA-New York, NY 10013
Fon +1 (0) 212 627 1999
Fax +1 (0) 212 627 9484
eleshowitz@dapinc.com

ISBN 978-3-86335-676-7

PRESENTATION HOUSE GALLERY

KÖLNISCHER KUNSTVEREIN
gegründet 1839

Canada Council for the Arts Conseil des Arts du Canada

BRITISH COLUMBIA ARTS COUNCIL
An agency of the Province of British Columbia

BRITISH COLUMBIA
The Best Place on Earth

NORTH VANCOUVER DISTRICT

Stadt Köln

KUNST STIFTUNG NRW